SAMUEL BECKETT

PHOTOGRAPHS

SAMUEL BECKETT

PHOTOGRAPHS

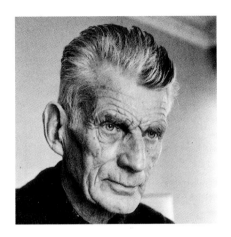

First published in the United States in 1996
by George Braziller, Inc.

Originally published in Great Britain in 1995
by Martin Secker & Warburg Limited,
an imprint of Reed Consumer Books Limited

Cataloging-in-Publication Data for this title is available at The Library of Congress.

For further information, please address the publisher:
George Braziller, Inc.
60 Madison Avenue
New York, NY 10010

ISBN 0-8076-1410-6

Printed and bound in Hong Kong

First Edition

INTRODUCTION

I

Thunder in the Index

John Minihan and I have collaborated before. I wrote the text to his photomontage of the last wake held in Ireland, in his County Kildare hometown of Athy not too far from my own rustication. (It surfaces again in Joyce's *Portrait* as the answer to a puerile riddle.)

His footage of Beckett rehearsing and tasting a drop of Guinness is as dramatic as anything Tissé ever shot for Eisenstein's *October* in the way of grainy atmospherics.

Sam Beckett, that *Terra incognita* ever receding, was never an easy subject to entrap. Here is a record of the last of the living Beckett and the final resting place in Montparnasse.

Beckett wrote of matters that few before him had attempted, touching the essential boredom of human life, human imbecility so testing of the Deity's much-tried patience, with a candour that went far beyond candour. A rippling, peremptory prose that was – what was the word? – illuminated, rock-steady with faith. That was Beckett.

For a writer working in Joyce's wake it was difficult to get out from under the shadow, thrice difficult if you were an Irish writer, unless you ignored his work altogether as did X and Y.

The Joycean *savoir faire* was uncommon, a matter of musical cadences, living falls. The *Meister*'s shadow darkened – lightened? – Beckett's early work from *More Pricks than Kicks* onward through *Dream of Fair to Middling Women* to *Murphy* (1938), before the influence was finally shaken off, exorcised.

1

A special torment was reserved for Beckett, an appropriate fate for a favoured disciple: to be crucified upside down. He saw our life out of alignment and in a special way; overseer of the mush, the stench, the deeps. The great precursor had set up the theme: wayward inwardness. Joyce himself had died of a surfeit of disappointments, famous himself yet his work considered obscure, as old Melville in the obscurity of the Customs and Excise office. His (Joyce's) last ur-novel had been almost two decades in the making, the arduous time-consuming erection of scaffolding, no routine job but a chronicle of the Celtic Unconsciousness itself in all its unplumbable murkiness.

He regarded it as his best work, saw it with a specially favourable (if purblind) eye; as the 'unusualness' of a mongoloid child is said to solicit a special mother-love, this was to be the father and mother of an impossible love. It was an equally impossible novel.

Beckett too was to become diverted into a far-from-Celtic mist (nothing clearly seen from *Echo's Bones* (1937) to *L' Innomable* (1952)) until his eyesight was corrected and the mists cleared; whereupon he advanced from strength to strength. His radio and stage work brought him into contact with professional stage people who would help bring his characters to a ready life; a nature austere and withdrawn learnt to accommodate the crowd.

For a fellow famously reclusive, refusing to give interviews and hating to be photographed, he has left a memory of warm friendships behind him and a body of work less cloistral than supposed, accessible to browsers of all persuasion.

The venerable Irish mirror held up to nature must needs be not only cracked but a distorting mirror. There are, to be sure, good times and bad. But you cannot do much in a dead place, and Ireland in the 1940s was stone dead, a moribund island buried by Dev, for his anointed one (Archbishop McQuaid with whom he had gone to college) to whisper the last rites over.

The two decades dating from the publication of *Ulysses* in 1922 to the death of Joyce and Yeats produced some work of exceptional liveliness, which included Beckett's *Murphy*, Flann O'Brien's *At Swim-Two-Birds* and *An Beal Bocht*, in a bucklepping Gaelic that mocked the sometimes oleaginous manner of the original (*An tOileanach*).

Taking the mickey is a venerable Irish custom, like droning away on the bagpipes, drowning the shamrock, not casting clouts before May is out, casting aspersions on you-know-whom, or the practice of dropping in uninvited on 'friends'.

I once asked the late Alex Trocchi what Beckett's French was like, what was he up to, and why write in French since he managed so well in English?

'Sam's taking the mickey out of the French language,' Trocchi said.

The Irish surnames look out of place in the French text – Malone, Macmann and Molloy, lost amid the murr and myrrha of things French. But no odder than Beckett felt himself as a solitary low-church Protestant highbrow amid the Catholic antiquarians and zealots. In due time *Molloy* would be converted into a faintly Latinised English with the help of the South African Paul Bowles, which left the author dissatisfied, as did the later translation help from the American Dick Seaver. He could not wholeheartedly endorse alternative versions at such a remove. *Watt*, in his own English, was dismissed as 'execrable'.

Joyce's archetypal mummies were superseded by Beckett's retarded and half-witted, men and women come down in the world, in a narrative fuelled by Godlike (or Godot-like) uncertainty and doubt.

Where now? Who now? When now?

'Next to great joy,' rumbled clubman Henry James, pulling on a thick cigar, 'no state of mind is so frolicsome as great distress.'

II

A Storm Blowing From Paradise

A mutual mistrust of what Joyce called the 'wideawake language of cutanddry grammar and goahead plot' led Joyce and Beckett off in different directions. The lapsed Roman Catholic believed the more the merrier and put in everything – incremental stockpiling, addenda piled upon addenda, until he went too far in *Finnegans Wake* (sans apostrophe). Whereas the sceptical ex-Anglican made it his dicta that the artistic process was a contraction, not an expansion. This can be checked by a glance at the published proof corrections on *Ulysses* and the abridgements displayed in Beckett's working notebooks. *Reductio ad absurdum* led to unimaginable departures, 'an unspeakable trajectory'.

What they both had in common was a playfulness, a scepticism and exuberance, a rhapsody of verbal energy; an art of a different order from any achieved up to that date. Art has always been bourgeois, when it could be something grander. The first inkling that a novel could be more than a story came to me with the reading of Joyce's *Portrait of the Artist as a Young Man*, published when Joyce was thirty-eight, read when I was about twenty-two.

Kate O'Brien's *Without My Cloak* (1931) and *The Land of Spices* (1941) were both banned by the Censorship of Publications Board. Beckett rejoiced to be found in the category of those authors 'deemed from time to time unwholesome', with his lexicons of wit's brevity, by one (seemingly) at his wit's end.

'Success and failure on the public level never mattered much to me,' Beckett wrote to reassure Alan Schneider, 'in fact I felt much more at home with the latter, having breathed deep of its vivifying [sic] air all my writing life up to the last couple of years.'

A prey all his life to a foreboding that never abated, for him the grey air was 'ever aswirl with vain entelechies'. There must have been a bitterness in the grey, grim air of occupied Paris that Beckett was alerted to; disguised as a Frenchman, cautious as a spy, acting as courier for the Resistance. They didn't want Sartre who talked too much, was swayable, blind in one eye.

Elizabeth Bowen as a child of five, prevented from reading, being walked by her governess from 15 Herbert Place in the fashionable part of Dublin, saw 'a sky for the favoured':

> Early dusks, humid reflections and pale sunshine seemed a part of its being. I used to believe that winter lived always in Dublin, while summer lived always in County Cork. By taking the train from Kingsbridge Station to Mallow one passed from one season's kingdom into the other's.
>
> When they first made me understand that I had been born in Dublin I said, 'But how? My birthdays are always at Bowen's Court.' A house where a child no longer is virtually rolled up and put away. So by having been born where I had been born in a month in which that house did not exist, I felt that I had intruded in some no-place.

<div align="right">SEVEN WINTERS</div>

The very *air* is different for Protestants and Catholics.

The air of occupied Paris was gun-metal grey, the field grey of the *Wehrmacht* officers who occupied all the best seats outside the cafés. Beckett had said famously that he preferred France (Paris?) at war to Ireland (Dublin?) at peace, and had returned there to save his soul, and to make himself as a writer. The 'fallen' city, the whore that had put up such a feeble show of resistance, could be forgiven. The Anglican lady who was to inherit Bowen's Court had the dead air of blitzed London in her fastidious nostrils, poet Mahon's 'unventilated slopes'.

III

After Embers

The existences of Anglo-Irish people . . . like those of only children, are singular, independent, and secretive.

To most of the rest of the world we are semi-strangers, for whom existence has something of the trance-like quality of a spectacle.

Elizabeth Bowen, BOWEN'S COURT

In Irish writing could there ever be an authentic Protestant note, unmistakably that, pure and simple? A diminuendo of sorts, a sorry Anglo-Irish *Schultzmusik*, a *De Profundis* fit for the Pale? And how would these same Protestants view their Roman Catholic neighbours?

The natives like to see themselves – even if only in a very poor light – as they had always imagined themselves to be (from the lies perpetuated in *Ryan's Daughter* and *The Quiet Man* on to the Wicklow simpletons of *Glenroe*, the long-running soap opera that would have astounded Synge who had tramped through the Wicklow glens and knew the people) *mutatis mutandis*, Nappertandywise, as . . . gas cards.

The bog poet Paddy Kavanagh of rocky Fermanagh, ever boggish in his ill-humour, refused Synge any insight whatsoever into the poor Aran-islanders (even if Synge had Gaelic, which Kavanagh hadn't), for Synge was a gentleman and worse still a Protestant gentleman of culture who had gone to Trinity and had travelled in Europe. Joyce himself could not but be caustic at the expense of the two Dublin society ladies of Protestant Ascendancy stock whom he transformed into the grotesques, Mrs Bellingham and Mrs Yvelton Tallboys, about whom Bloom (or his more active subconscious) had erotic daydreams, a sort of onanistic counterplay to the invisible Martha Clifford. The dreams were sado-masochistic in character; the urgent need for a jolly good hiding.

Myles na gCopaleen of the *Irish Times* objected to the Joyces speaking Italian (no doubt Triestine argot) among themselves. That Beckett wouldn't read *At Swim-Two-Birds* because of a slight the greenhorn author had made against Joyce means that we have come full circle.

Possibly it takes a near (or neo-) outsider to catch the plangencies and bitter wit of the oppressed insider; for a Protestant writer to examine it without any condescension is next door to impossible.

Beckett, for whom the impossible would always be a challenge ('I can't go on'), does it magnificently. Nothingness does not confront another nothingness but implies something opposite to it and in highest contention, to keep the void from pouring in. Such contention in the skill keeps the void away, stays the mulligrubs.

Though his fellowmen may be jocularly addressed as 'fellow bastards', individuals as 'swine', and humankind at large as 'the sniggering muck', the accumulated energy of the verbal strategy and frolics cannot but endear the dullest browser or the most muddy-minded casual reader to the works of this peerless penman 'frozen by some shudder of the mind'; always with a new surprise in store around the next corner, over the page, the verbs taking off and the pronouns dancing, afrolic; even if the persistent whisper in the head says 'Thou fool thy soul'.

> . . . that time in the end when you tried and couldn't by the window in the dark and the owl flown to hoot at someone else or back with a shrew to its hollow tree and not another sound hour after hour hour after hour not a sound when you tried and tried and couldn't anymore no words left to keep it out . . .
>
> THAT TIME

As with a new and difficult music as yet unperformed, the texts can be read as flawless as they stand; only dud performance can flaw them. When asked what he valued in his own

work, Beckett replied 'What I don't understand'. It is perhaps no coincidence that the two actors who professed themselves baffled by Beckett gave outstanding performances - Peter Bull as a very testy Pozzo (the absentee landlord *in extremis*) in the original Criterion Theatre production; and the peerless Paudge Magee growling away in any Beckett-staged *Stück*. Give a dog a bone.

Regarding the modern hero of fiction as a shadowy personage (Proust's bedridden and virtually nameless hero, the guilt-ridden heroes of Kafka and Camus, or the retrogressive Oscar who never grew beyond the age of three in *The Tin Drum*), you may well ask:

Q: Why heroes so spectral and shadowy?
A: The hero of gigantic appetites, of journeys to the ends of the earth, had been replaced by the hero as multiple consciousness, who does not (cannot?) travel at all, except in his own head. The perceiver has taken over from the participant.

Joyce (who was going that way anyway) invented a multiple consciousness which he called 'Leopold (Poldy) Bloom', a much-cuckolded seller of advertising space, son of the suicide father Virag, of Hungarian Jewish blood who had married Mary Higgins. Assembled craftily over a period of seven years, he (Bloom) was intended to represent or stand in for the Collective Celtic Consciousness, or CCC, that was thought to be injured, the sense of *déjà vu* that invested the land itself; the sense of strangeness, of both belonging and not belonging, of being hard-done-by, of being betrayed, of alienation which I take to be the trade mark and sorry plight of the 'mere Irifh', their *status quo*. An island race obliged to live close to itself *on no matter what terms*. The smaller the island the bigger the neurosis.

Brian O'Nolan, the speaker of Tyrone Gaelic, would pay grudging homage to Joyce, but in

the next breath would have to disparage him, and to Beckett of all people, who would in turn refuse to read *At Swim-Two-Birds* because of the imagined slight to Joyce, and would in turn tell it to me in the Giraffe Restaurant in Klopstockstrasse in Berlin. 'Joyce,' spat out Myles the begrudger, 'that refurbisher of skivvies' stories!' It may have gone down well as a public sally in the Scotch House or acid aside in the Pearl Bar, but it didn't go down well with Beckett, deviser of the voice and of its hearer and of himself, most certainly not.

James Joyce, dare one say, was in a sense a refurbisher of skivvies' stories – this is truer of *Dubliners* than of *Ulysses*. Irish art was, he said, the 'cracked looking-glass of a servant'. Joyce, outside his own land, was to be the oracle for the Unsaid, the Unspeakable, the silent generations. Not that they were silent, that was not their nature, among themselves; but unrecorded, unknown *outside* of themselves.

I once asked Beckett his opinion on Joyce (the awe-tist *ne plus ultra*, not the man), in one word. He didn't hesitate: 'Probity,' said Sam stoutly. I've heard it defined as a ferocious application to the task in hand.

The begrudger, Brian O'Nolan, being a civil servant, had to invent a number of aliases to write under. As Myles na gCopaleen (Myles of the little horses, the ponies) in his Cruiskeen Lawn (or The Full Jug) column of the *Irish Times*, over two score years, he had invented perhaps his own best character; a conglomerate being called The Plain People of Ireland, as stand-ins for the entire Celtic Unconscious that was well aware of itself, if unrecorded; the Volk of the Irish Ego, the yolk of the Gaelic egg.

It was not exactly *invented*, because it was there already. The real hand that wrote *At Swim-Two-Birds* belonged to a nameless pseudo-narrator, the suicide hand that had

scrawled in blood thrice in German: Goodbye, Goodbye, Goodbye. The Red Hand of Ulster? The dismembered extremity clutching at 'the bare, hard, dark, stinking earth' that is home, must be home.

In 'real life' (so called) the 'uncle' had been the real father of Brian O'Nolan, sometime student at University College, Dublin and bane of the Debating Society.

The brother – I mean one of his *real* brothers – Kieran O'Nolan, spoke to me about the composition of this flush oddity with a kind of grudging admiration, or admiring horror. For it was sucking back everything into itself like a humming Hoover eating dust and dirt, and he considered himself a lucky man to have barely escaped the insuck, the inflow.

Cuckoo operations are carried on in *Gulliver's Travels*, *Murphy* and *At Swim-Two-Birds*. A large egg is laid in a small nest and the innocent hatching out of the false chick (already, in the egg, twice the size of the putative mother) carried on by the innocent parent-bird, the pseudo-mother.

In *Gulliver's Travels* the poor condemned Irish – 'old savage Irish,' wrote Swift to his friend Pope – are seen alternately as giant and dwarf, controller and controlled, master and slave. Gulliver either striding about in seven-league boots and dragging the Blefuscudian fleet off its moorings, or carried about in a box like a ferret, tied down by the roots of his hair by creatures the size of his thumb and interviewed by a midget Queen who insists on correct protocol.

The nameless hero of O'Nolan's (hereinafter Flann O'Brien) first novel will become a nameless hero with a wooden leg in the next; a murderer by proxy who descends into a revolving Celtic hell manned by his deadly enemy, the rozzers (Civic Guards, offering bags of sweets), in *The Third Policeman*, written soon after.

I first encountered *Murphy* in Greystones circa 1950, when John Beckett loaned it to me. He sometimes came home to Greystones to see his widowed mother. Both spoke familiarly of Sam, who had visited them when deaths occurred. Sam loved the countryside, loved Bray Head, the bright yellow 'ling'. Beckett *relicti* abounded in Blacklion Cemetery overlooking the harbour.

Murphy, which I swallowed whole at one sitting, is one of those once-in-a-lifetime novels that cannot but inspire affection. It is lit by a special light, a loving favour, and the kite-flying hill on Hampstead Heath became for me a special place on that account. The opening is unforgettable:

> The sun shone, having no alternative, on the nothing new. Murphy sat out of it, as though he were free, in a mew in West Brompton.

The opening two sardonic clauses are as dumbfounding as unthinkably masterful moves in chess. It reads as a much *stouter* novel than its 158-odd pages (and odd they are) would concede; Celia is Beckett's most sweetly realised female character. I was later, through Arland Ussher, to meet the original of Ticklepenny, who was not prepared to talk about Beckett.

The markedly anthropoid Miss Counihan has a bust which is 'all centre and no circumference'. I had to wait some years to get the point of this joke, until it was revealed to me in *The Book of Imaginary Beings* by Borges, the blind Argentinian seer. He quotes Pascal: 'Nature is an infinite sphere whose centre is everywhere and whose circumference is nowhere'. Borges set out to hunt down the metaphor through the centuries. He traces it to Giordano Bruno (1584): 'We can assert with certainty that the universe is all centre, or that the centre of the universe is everywhere and its circumference nowhere'. But Bruno had been able to read it in a twelfth-century French theologian, Alain de Lille, a formulation lifted from the *Corpus Hermeticum* (third century): 'God is an intelligible sphere

whose centre is everywhere and whose circumference is nowhere'. He finds the metaphor again in the last chapter of the last book of Rabelais' *Pantagruel*, in Empedocles (who casts all things about), in Parmenides, in Olaf Gigon (*Ursprung der griechischen Philosophie*, AD 183), who had it from Xenophanes six centuries before Christ, when he offered to the Greeks a single god. And I found it again in Beckett's *Murphy* (1938):

> 'Not know her is it,' said Wylie, 'when there is no single aspect of her natural body with which I am not familiar . . . What a bust! . . . All centre and no circumference!'

Metaphysics as a branch of the literature of phantasy? The Borgesean sources are innumerable and unexpected. He saw Lord Dunsany (!) as a precursor of Kafka: Browning's poem 'Fears and Scruples' also foretold Kafka's work. In this correlation the identity or plurality of the men involved is unimportant: 'The early Kafka of *Betrachtung* is no less a precursor of the Kafka of sombre myths and atrocious institutions than is Browning or Lord Dunsany'.

Murphy had boasted of conducting his *amours* along the lines of Fletcher's Sullen Shepherd. Professor Neary and his henchman Wylie discuss Murphy. What is it that women see in him? Was it his surgical quality?*

Oh no.

The comic novel, operating in some zone outside History and Time, *writes itself*, discovering its theme and form largely independent of its author; rather in the hit-and-miss manner in which Alexander Fleming discovered penicillin; with the help of mucus from his nostril, saliva, tears and the whites of eggs.

* *Murphy*. Slang. 1881 (Use of common Irish surname). A potato. Murphy('s) Button. Surg. 1985. A device invented by J. B. Murphy, an American surgeon, for reuniting the parts of an intestine after complete severance.

Both Beckett and O'Nolan had independently admitted to me that they could see no virtue in their first novels.

The young Liam Redmond returned from Paris with two volumes of the Shakespeare & Co first edition of *Ulysses* secreted in his baggage. He lent one to his friend. When he had got through one volume, O'Nolan asked for a loan of the second, protesting that he was 'only half educated'. In later life he liked to disparage Joyce, as did Nabokov.

Beckett came out of Joyce like the cuckoo out of the Irish egg. ('There's no end to the earth because it's round,' marvelled Bloom.)

IV

Fistula and Cyst

In the first letter Beckett ever wrote me from Paris the line occurs, but I couldn't read it. The calligraphy was a beast: the hasty hand of a hard-worked doctor firing off prescriptions. Eventually Peggy Beckett, the mother of John, deciphered it as: 'Despair young and never look back'.

Oh most excellent sack! Get your own suffering in order early, stow your gear and buck up, messmates. Excellent advice for one setting out on life's journey. Anticipate squalls.

I first met Beckett during the Criterion production of *Godot*, which had effectively bowled me over. He was coming down from Godalming with Pete Woodthorpe (Estragon) and a lady who had been to Trinity with him. John and Vera Beckett were then living on

Haverstock Hill, and invited my wife and me over for a supper (silverside of beef, as I recall, done quite rare), to meet Beckett.

The party from Godalming arrived maybe an hour late. I wondered whom I would meet, Democritus or Heraclitus. Well, in the event, neither. It must have been Sunday. The murmurous Dublin accent was lovely to hear; he was not assertive, taller that I had expected, carried himself like an athlete. He had a copy of *Texts for Nothing* in French on the mantel, stood with me after the meal, asked my wife's name and inscribed this copy.

The following evening we accompanied the Becketts and Michael Morrow to Collins Music Hall in Islington, where the young Chaplin had performed in Fred Karno's troupe. A nude chorus girl was pushed across the stage on a bicycle, but what affected Sam Beckett was the row in stitches at Mr Dooley, who gave a rapid-patter monologue on what the world needed, which was apparently castor oil. It was in essence Lucky's outpourings at the Criterion. Beckett was leaning forward, looking along the row. On the way out we ran into Mr Dooley and introduced him to Beckett, of whom he had never heard; Mr D. was chuffed that Monsieur B. had liked his patter. It was all good clean fun.

Vaudeville appealed to Beckett. The farcical had to be given its head, the hats briskly exchanged. Brecht called it 'crude thinking' (*das plumpe Denken*), a device to liberate the metaphysics. Pratfalls, skids, banana skins.

The austere playwright, thought to be so reclusive, wasn't so reclusive after all, as close and enduring friendships with actors and actresses testify; as did the business of conducting much of his social life in cafés and bars. He seemed to be well aware of what was going on in the world at large, lived in no ivory tower.

He himself was not cold and inspired warm affection in others.

> When you fear for your cyst think of your fistula. And when you tremble for your fistula
> consider your chancre.
>
> <div align="right">MURPHY</div>

Watt (225 pages), datelined Paris 1945, written in English, resumes from where *Murphy* left off in 1938, composed in bursts to keep his hand in when hiding from the Gestapo in deepest Roussillon, and finished in Paris when he was searching for the knockabout vaudeville style of *Godot*. It has a quite deliberate *longueurs*. *Mercier and Camier*, long suppressed by the author, contains preliminary intimations of the interrogations of *Godot* ('They didn't beat you?. . . ') and already there are echoes of the great radio works ahead, the dramacules for the air. Nothing would ever be wasted.

Sloppiness, blur, was anathema to him; he brought a new astringency into writing. He was opposed to stale innovations the time-honoured usages and abusages of the antiquarian Gael. He was a caution. He was his own man.

George Moore of Moore Hall, Mayo, the 'genuine Irish gent' lampooned by the younger and malicious Joyce, was only playing at being a Frog, the boulevardier and Parisian aesthete ('Life is, *au fond*, so limited, so *diabolique*, *n'est-ce-pas*, between cocktails and *thé?*') was a mask behind which one recognised a cherubic flushed face. The honed style was honied with high aspirations.

A thinner and more authentic Hiberno-Gaul came with Monsieur Beckett's progress towards acceptance by Editions de Minuit. He had paid his dues, stabbed once by a *clochard*, he had shed his blood for France. France proud, fallen, occupied, freed; and Beckett himself was part of these operations, even if he shrugged off his *Crux de Gaulle* (sic) as 'Boyscout stuff'.

But you don't play games with the Gestapo. In his evolution as a writer in English and French, a whole world separates *Murphy* (1938) from *Molloy* (1951). A world war separates them, a way of viewing life, the acceptance of one's lot, one's tenure here on earth.

Up ahead are the mourning figures, robed and nightcapped, 'bringing night home', in the starless, moonless heaven of his later work. The funambulistic staggers of *Play* (1964), *Not I* (1972), *Footfalls* (1975), *Ohio Impromptu* (1981), *Catastrophe* (1982) and *What Where* (1984) cannot conceal the fact that the Gestapo weasels are at work in the long burrow again; in *Nacht und Traüme* more specifically.

Certain hidden factors of the Occupation festered in his mind, with the knowledge that an authentic torture chamber was operating in Paris at X. In those years he lived in the sixteenth *arrondissment* at Y, and would have passed it on his way to Z. If the Gestapo noticed Beckett in the street, they saw only another emaciated, thin-featured Frenchman passing by. He had reduced himself almost to nothing.

> Where were we. The bitter, the hollow and – haw! haw! – the mirthless. The bitter laugh laughs at that which is not good, it is the ethical laugh. The hollow laugh laughs at that which is not true, it is the intellectual laugh. Not good! Not true! Well well. But the mirthless laugh is the dianoetic laugh, down the snout – haw – so. It is the laugh of laughs, the *risus purus*, the laugh laughing at the laugh, the beholding, the saluting of the highest joke, in a word, the laugh that laughs – silence please – at that which is unhappy.
>
> WATT

The dreamer and his dreamt self. Sun long sunk behind the larches. Fade out dream.

Blind Borges had a theory that all the great books of the world might have been written for children, that all story-telling tended towards the conditions of the fairy tale.

Ideal reader in search of an ideal insomnia, hear this: Our life is a story told. Perhaps that is why children love to hear stories of the beginning of the world. We were weaned on terrifying yarns, it came with our mother's milk; from her lips we heard the saddest stories for beginners: Dick Whittington and his Cat – banishment. Rapunzel – gruesome intimations of the coming sexual combat. The girl imprisoned in the tower becomes Mary Queen of Scots kneeling to the headsman with a Skye terrier hidden up her skirt; becomes Joan of Arc watching the faggots being lit, and the greatest faggot of them all, Jean Genet – assuredly no saint – the man who had supped deep with horror, said that her menses had come the night before and she had to ascend the scaffold steps with a 'rusty stain' at crotch level on her virgin white smock, and had that humiliation to endure along with the taunts of the English soldiers.

Many stories and novels carry on their backs a load of atrocious bad news, as the *bucklicht Männlein* (little hunchback) his hump. Indeed the implication inherent in our readings and interpretations of free-floating texts is that we knew it all along, for even the oddest and cruellest fictions had a familiar ring to them. Beckett praised de Sade for his style.

Winding its serpentine way through all fairy tales (fabled by the Daughters of Memory, the Misses Mneme) is the legend that we cannot forget, that hurt and upset us long ago, even before we could read; all those variations of the theme of banishment, from the home, the hearth, the heart, the homeland, the bed.

The cruel stepmother becomes the witch in the forest, the brothers have turned into swans; before Adler and Jung were Brüder Grimm and Hans Andersen, the gentle giant, the frustrated man; and before them again Brentano and anthropology. And long before *them*, the Dark Ages and the yarns of illiterates never committed to writing but carried in the head before parchment and vellum, before the city, the nursery, the little lie of

solicitude, the big lie of 'caring'. In a word, Inglenooknarration, gruntings and groanings and gushy whisperings; Gobbledegook.

And before that again, a much more numerous company, our true forbears, the Frightful Ones: the vasty multitude of our speechless and indeed repulsive ancestors warming their bloodied hands before a communal cannibal fire.

Out of these depths rises the story.

Varying from country to country, from language to language, down the centuries, offering innumerable versions of the one yarn that would change; story become interdict become precept – the story of the Fall, of the expulsion from paradise, of the angel with flaming sword.

Consider the multiple stories of exile: Jean-Jacques Rousseau, who invented the Noble Savage, locked out of his walled town; Dante in exile, Joyce and Beckett in their chosen exiles. Life is a story told.

When told well enough the story outlasts the storyteller, triumphs over oblivion. All the best stories in the world are about dispossession; of lovers in full flight, couples eloping from an angry father, from the cuckolded husband. Our Diarmuid and Grainne, Isolde and her fancy man (who had bad halitosis), Jim Joyce and Nora Barnacle (whom some said could hardly spell her own name), Willy Reilly and the Colleen Bawn. Not to mention Paolo and Francesca whirled about and about in their cloud. The flight of secret love into the unknown.

Our abominable past.

Nietzsche spoke of the void eternally generative. The abyss itself has rarely been subjected to such close scrutiny since the sour grapes of the great Jacobeans. Hear the

melancholy Irish cadences come throbbing through the French and English texts, mournful as sea-warnings from the Kish.

The angle of attack was always unusual and unexpected, a pincer-movement directed at the heart. Nothing seemed to reduce Beckett's characters, male and female and mostly getting on in years; they cannot be put down, for they themselves can descend no lower. The seedy solipsists get the great mileage out of their misery; unceasing monologues tending towards the condition of unanswered prayers. Misery, with them contagious, never seems to reduce them; none plead, though close enough to abject misery to grovel. There is a continuous Court of Appeal in session.

Instant *vagitus* recorded, cry, then silence; the prescription is a little daunting and would quickly reduce itself to preciousness in hands less assured. Doddering old Democritus setting forth to seek misfortune encounters whom do you suppose but the young Heraclitus just arriving, grinning from ear to ear.

By some extraordinary means, hard won in a hell of private grief known only to himself, Beckett from his retreat in the Marne mud had issued directives more or less undecoded and direct from the psyche itself, that silent over of suffering in silence. All lead back to the Self, where all ideation has its seat, in the brain. Lemuel Gulliver cannot put the King of Laputa in his coat pocket.

Beckett never succumbed to the merely anecdotal, nor was he too free with messages.

> . . . alone on the end of the stone with the wheat and blue or the towpath alone on the towpath with the ghosts of the mules the drowned rat or bird or whatever it was floating off into the sunset till you could see it no more nothing stirring only the water and the sun going down till it went down and you vanished all vanished . . .
>
> THAT TIME

The paradox is that the story swamps the storyteller, outlives (outlasts) the author. The voice crying out 'Arise, ye wretched of the earth!' has only that message and cannot stop crying it. The idea behind the story is perhaps to rid the *Durée* of its ancient horror, its fixity of purpose, its hostility, its baleful intent; the drift being that Time itself must have a stop, that our lifespan here on earth must end.

All dreams turn into pointless stories as soon as we tell them to someone. But dreams are by their very nature extraordinary; the true nature of the dignity of man is that all is extraordinary, at least potentially. The core of the story is never quite found, the centre never quite arrived at but gestured to, from a safe distance. Anna Karenina is forever coming downstairs, Ulysses is forever sailing by, his ears blocked up with wax, the Sirens cannot stop singing, the fireworks are always rising up over Mirus Bazaar, the Good Fairy (safe in Pooka's pocket) is always losing that hand of poker (the stake: a simple soul just born), Jack Mooney is forever climbing upstairs with two bottles of Bass under one arm.

Samuel Beckett kept himself to himself in an even more cloistral way than his austere mentor Joyce, who had after all his family as a bulwark against the herd, an inner ring of bonding that expanded with the years on the arrival of grandchildren; though he (Beckett) could unbend with Magee and McGowran, no intellectuals, who had some intuitive understanding of what he was after. Despite his frigid bearing and frosty mien, there was something warm and endearing about him. Few if any ever called him Samuel; it was always Sam. If he liked you, well and good, you were instantly accepted into the closed circle, the enclave. He gave with an open hand and had to be taken with the same reciprocal spirit, as unstintingly. Was it this that inspired affection, or was it his work, so

20

affecting, or was it a combination of both? One was privileged to know Sam Beckett, for his likes will not come again; such generosity of spirit was rarer than radium.

With Sam Beckett you could never envy the genius because it was housed in the man; no writer had ever done less to conceal the treachery of that shelter.

AIDAN HIGGINS

SAMUEL BECKETT Paris
 10·4·85

Dear Mr Minihan

Thank you for yr letter of April 2.
I should be glad to see you in
Paris – provided you leave yr
camera at home.
 Bett.
 Sam Beckett

PHOTOGRAPHING BECKETT

Samuel Beckett's face is as familiar as his characteristic images: a tree, a country road, tramps, dustbins, boots, tape recorder, bananas. A still photographer's dream sequence, the magic of light and shade with only the sound of the camera shutter spoiling the silence.

The opportunity to photograph Samuel Beckett came in 1980. Sam was in London to direct *Endgame* at the Riverside Studios with the San Quentin Drama Workshop. We agreed to meet at the Hyde Park Hotel. His room overlooked the park. Sam loved walking and would stroll through the park after rehearsals. I brought along a selection of my photographs of Athy, Co Kildare, with a sequence on the wake of Katy Tyrrell at Sam's suggestion. As I watched him looking at my photographs I thought how fortunate I was to be in his room to photograph this intensely private man.

We kept in touch. I would photograph various productions of his work and send him the pictures. Beckett wrote me one of his distinctive cards saying that he would be glad to see me in Paris provided I leave my camera at home. I eventually got to Paris in December 1985 for a weekend. I met Sam in his favourite meeting place, Le Petit Café, on Boulevard St Jacques, very close to where he lived until his death in 1989.

Sam would meet all of his friends at the café which was part of a large hotel complex and which gave him a sense of anonymity. I arrived with a bottle of Irish whiskey. Sam spoke about the photographer Brassaï whom he knew as a sculptor; I told him I was familiar with Brassaï's photographs of Paris lowlife.

I mentioned the many Beckett celebrations Paris had organised for his eightieth birthday and that I would like to take a new portrait. With no hesitation he said that I should return

at three o'clock the following day and bring the camera. I was very excited and made sure that I arrived at the hotel early to secure a seat near the window, as Sam would have chosen a more secluded spot. He arrived on time, smiling as he spotted me at the window. Over numerous coffees and whiskeys we talked about mutual friends and the price of a pint of Guinness in Dublin. He said that he was not having the best of health, and suggested that I take a photograph at the table, the place full of Japanese tourists all with cameras – oblivious as to Sam. As I put the camera to my eye and made the exposure, Sam put his hand on the table, his eyes looking away from me. I took one shot – there was very little available light left. Outside on the Boulevard St Jacques I took some more photographs – that was it. I said 'Goodbye', Sam said 'God bless'.

JOHN MINIHAN

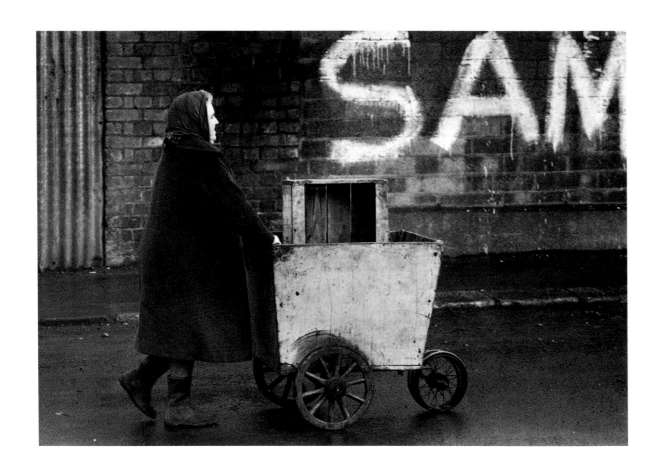

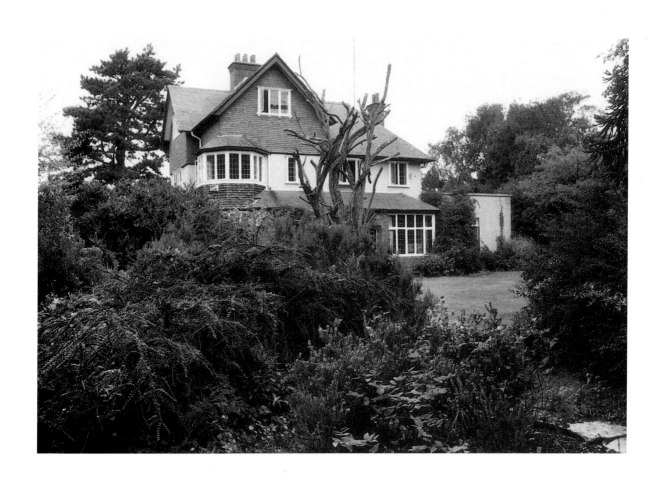

Cooldrinagh, Dublin – Beckett's birthplace

Sam was born on the second floor room with the bay window in 1906.

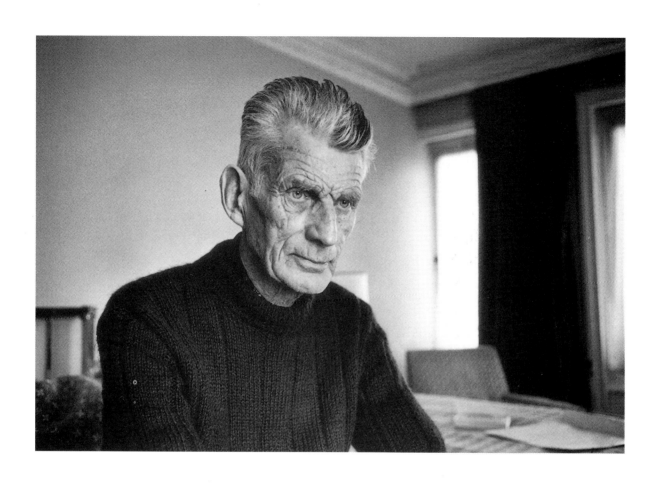

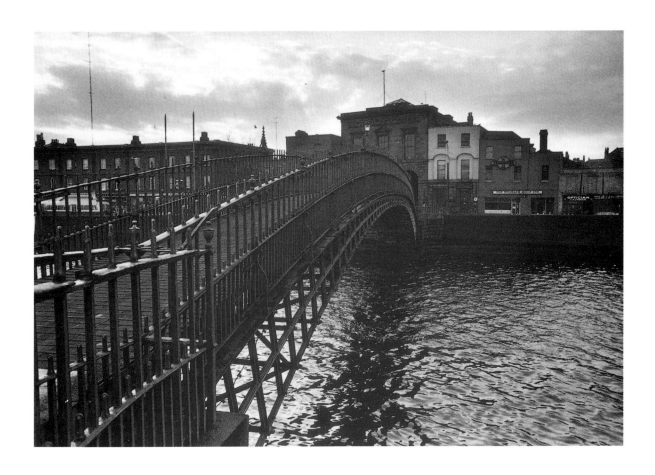

The Halfpenny Bridge

'Whom should Harry meet on the crest of the metal bridge but Walter Draffin, fresh from his effeminate ablutions and as spruce and keen as a new-ground hatchet in his miniature tails and stripes.'

More Pricks Than Kicks

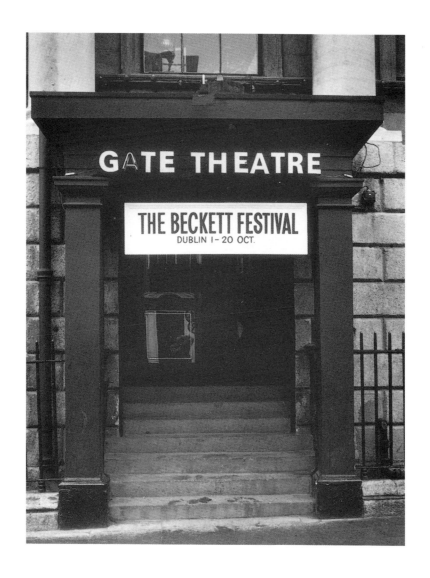

The Gate Theatre, Dublin

'Didn't I have the dishonour once in Dublin?' he said. 'Can it have been at the Gate?'

Murphy

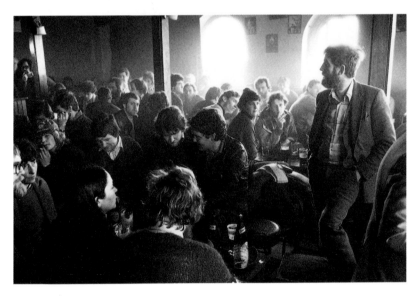

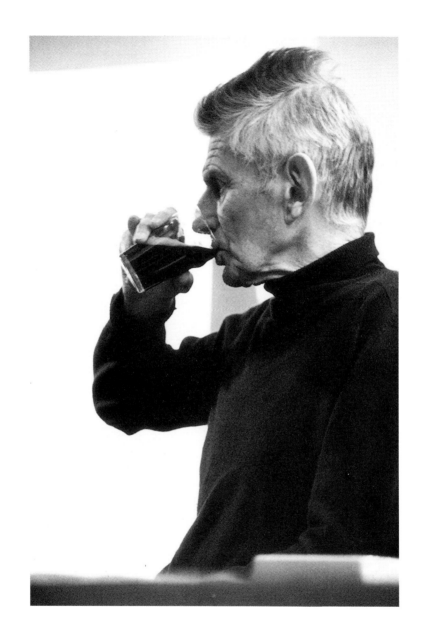

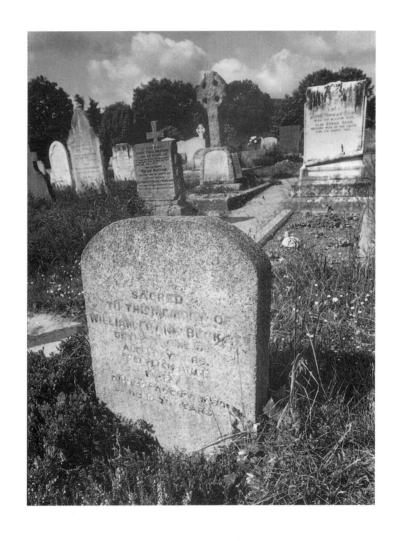

Grave of Samuel Beckett's father and mother, Redford Cemetery, Greystones, Co Dublin

'I visited, not so long ago, my father's grave, that I do know, and noted the date of his death,
of his death alone, for that of his birth had no interest for me . . .'

First Love

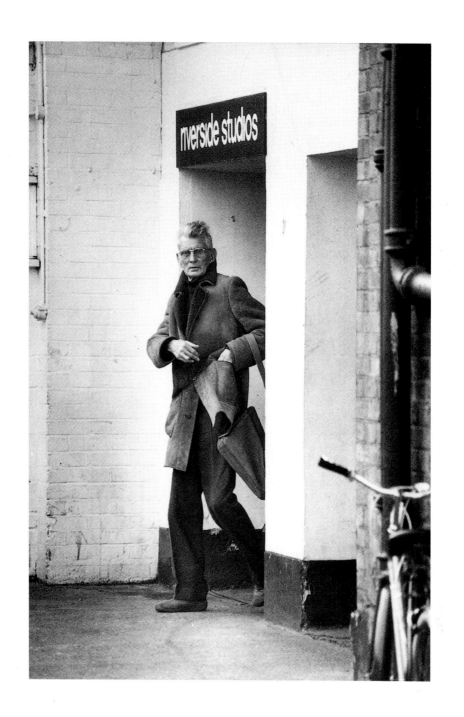

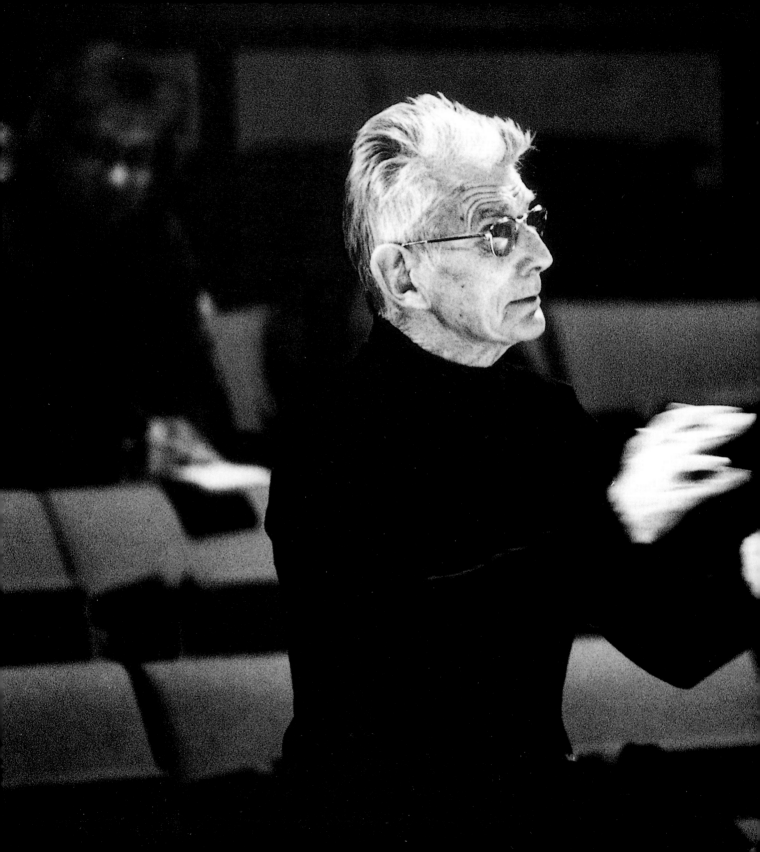

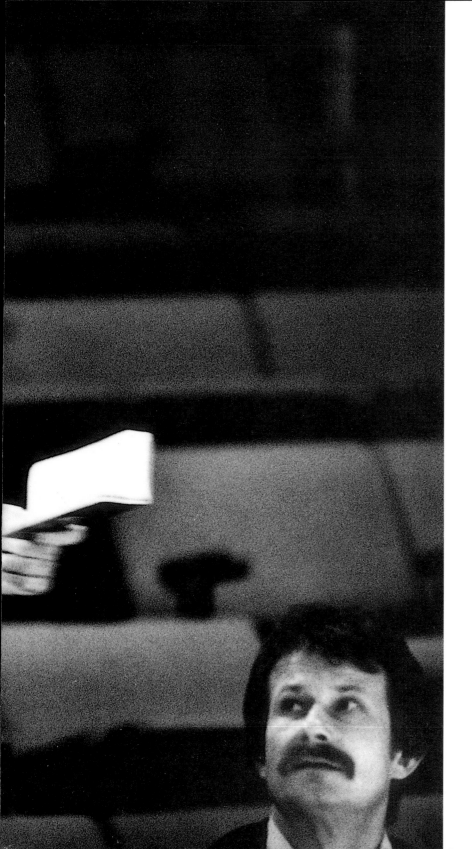

Beckett directs Beckett at the Riverside Studios in 1984, watched by the leading German director, Walter Asmus, who has now taken over the mantle of directing Beckett work around the world.

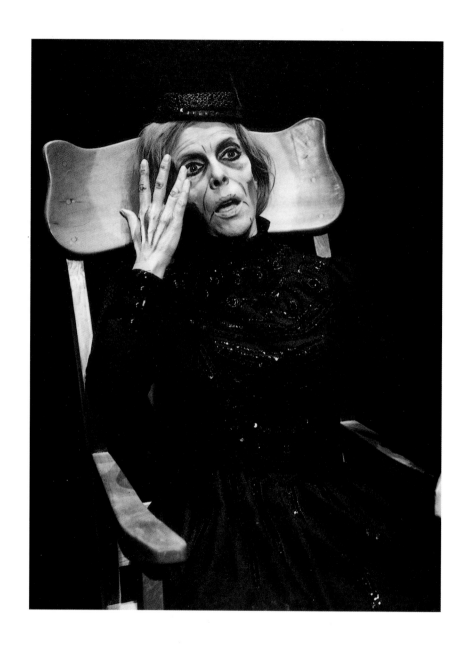

Billie Whitelaw, a favoured Beckett actress, performing *Rockababy* at the Riverside Studios, London

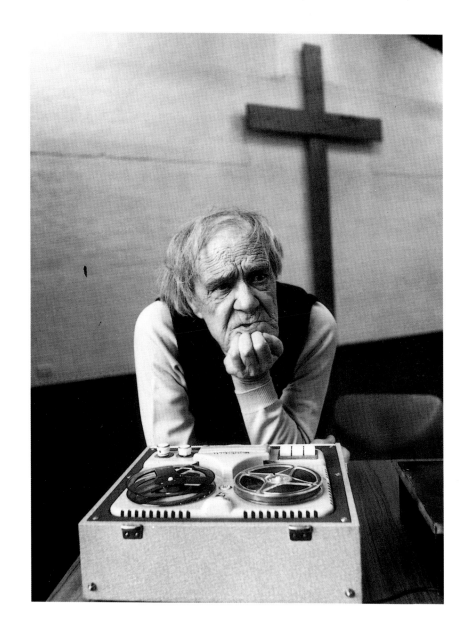

Max Wall was one of the last giants of traditional music hall.
He was also acclaimed for his performance of *Krapp's Last Tape*.

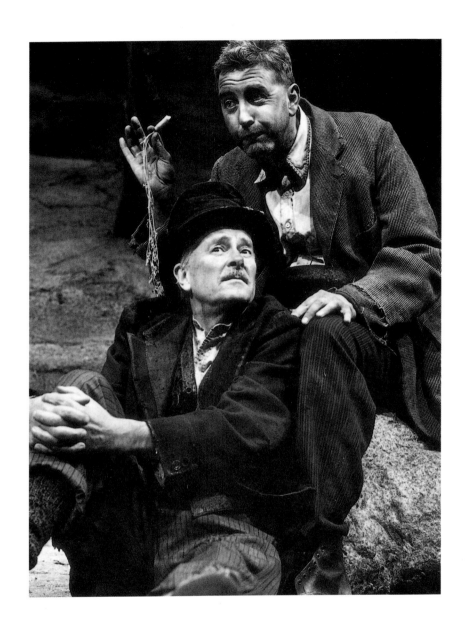

Waiting for Godot at the National Theatre, 1987
Alec McCowen as Vladimir and Jon Alderton as Estragon.

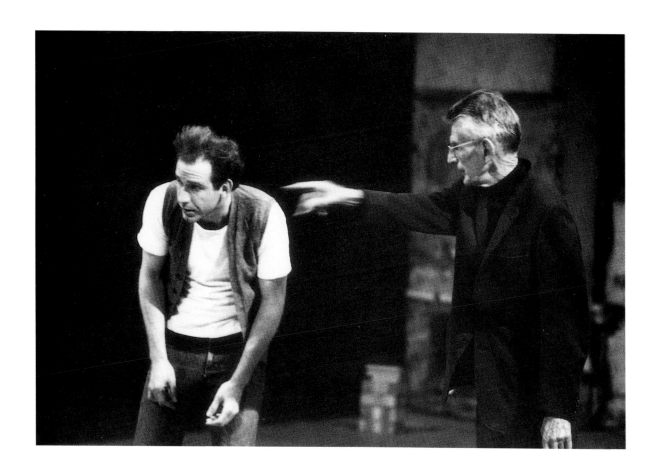

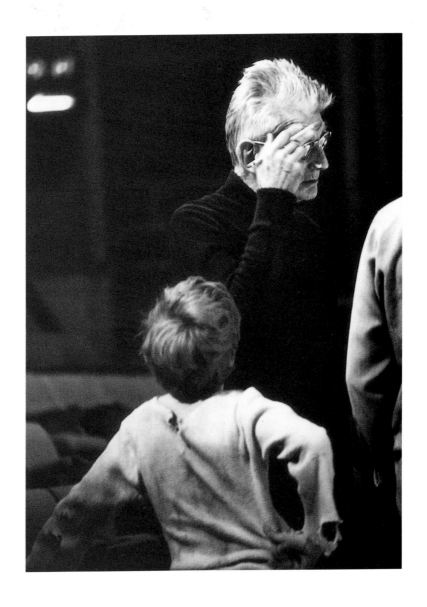

'Boy: Mr Godot told me to tell you he won't come this evening but surely tomorrow.'
Waiting for Godot

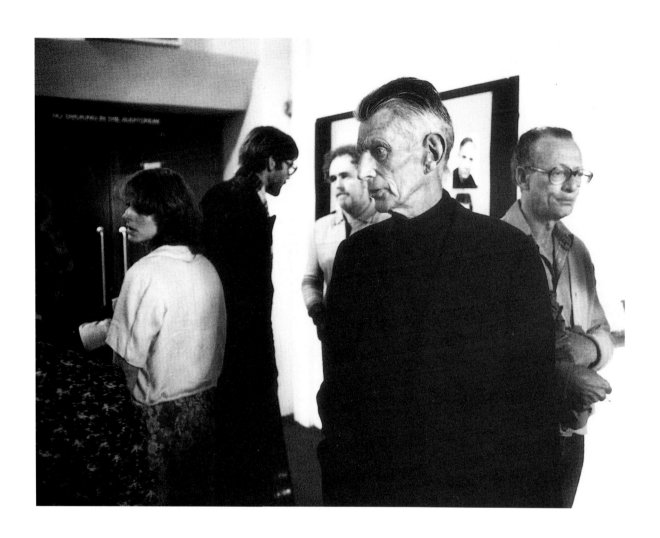

41

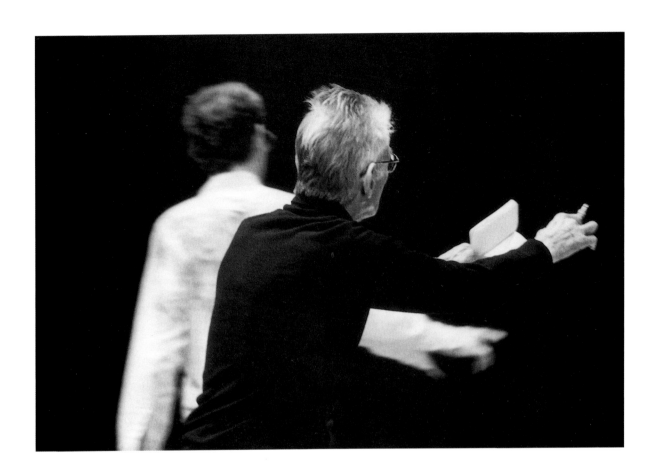

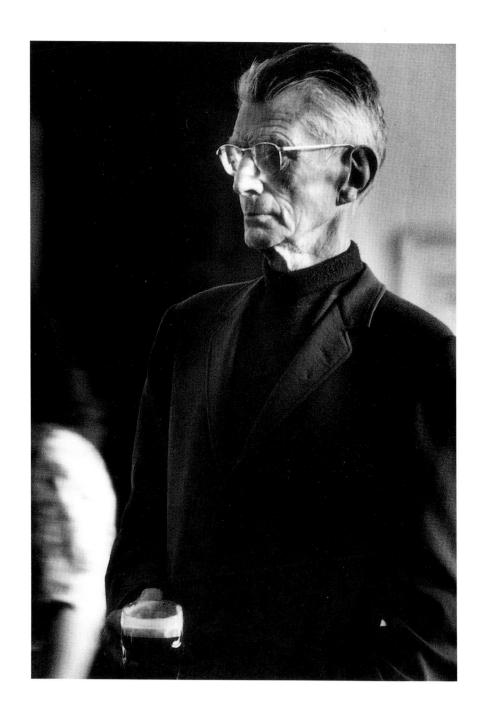

43

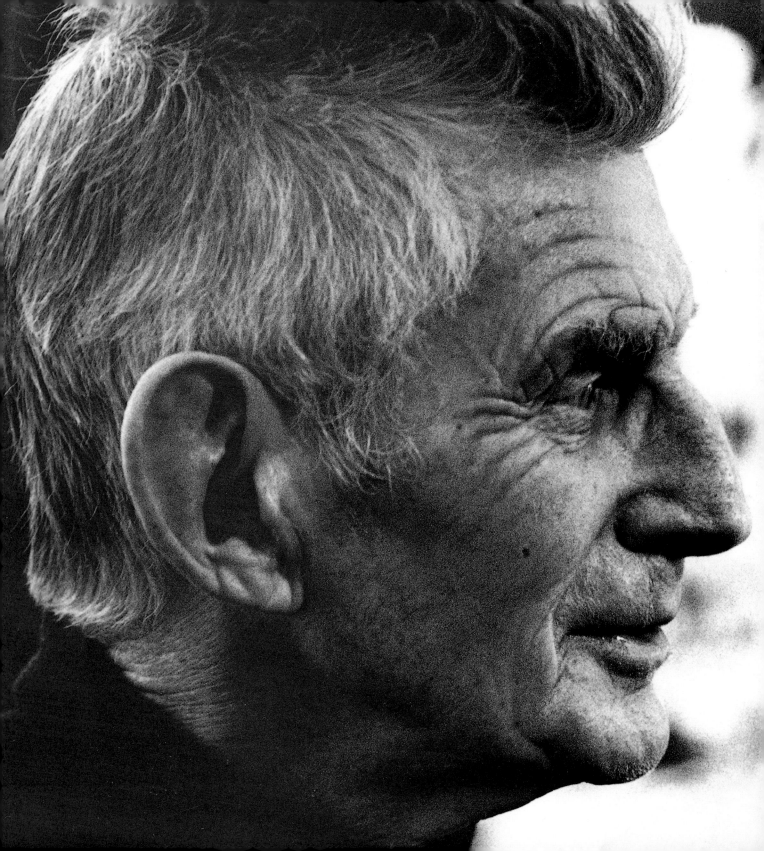

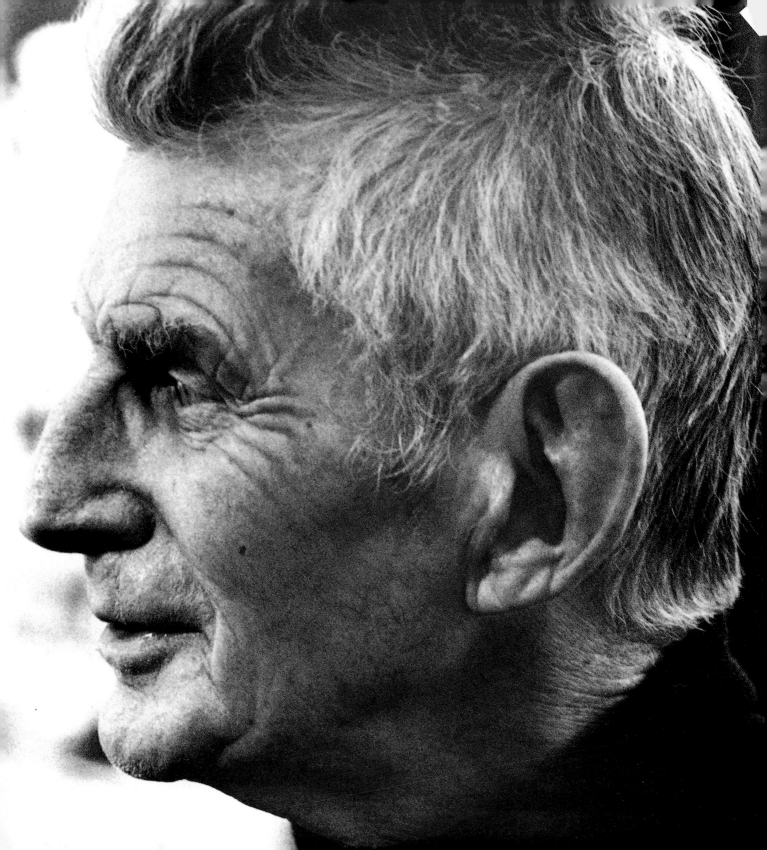

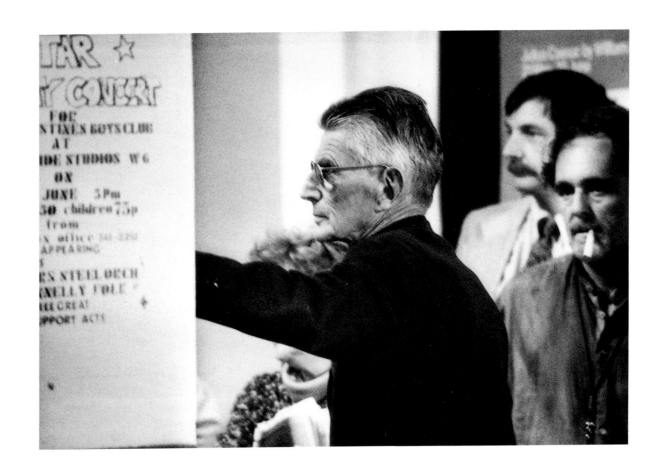

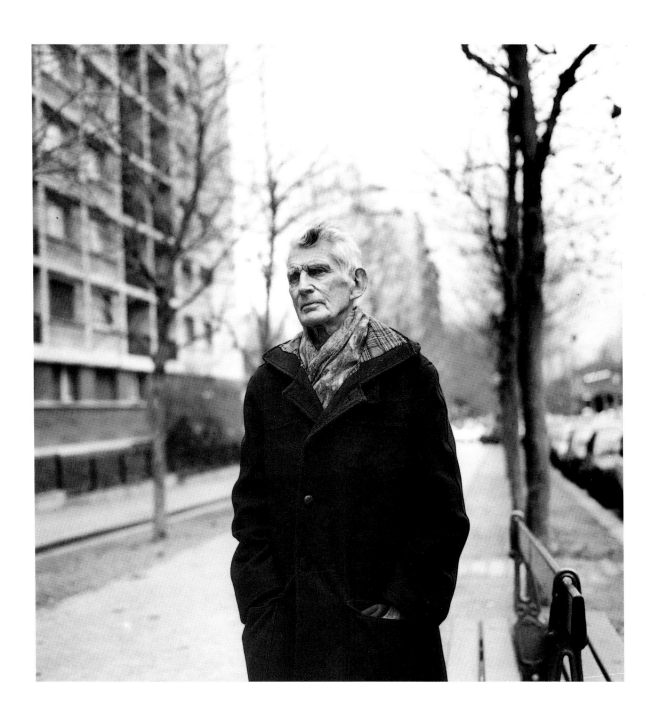

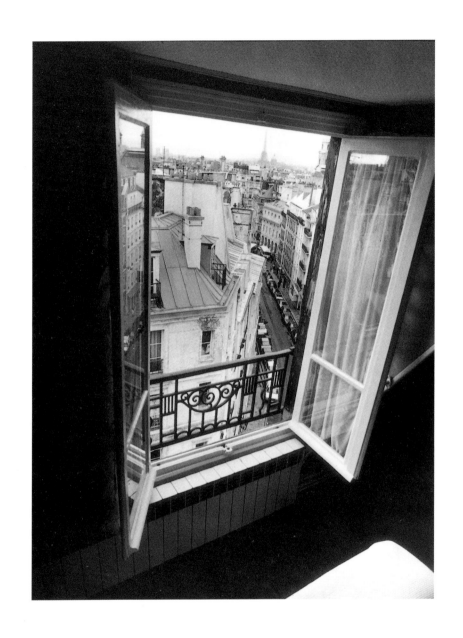

Window view from the Hôtel Trianon of the Rue de Vaugirard

Samuel Beckett wrote his first novel, *Dream of Fair to Middling Women*, here.

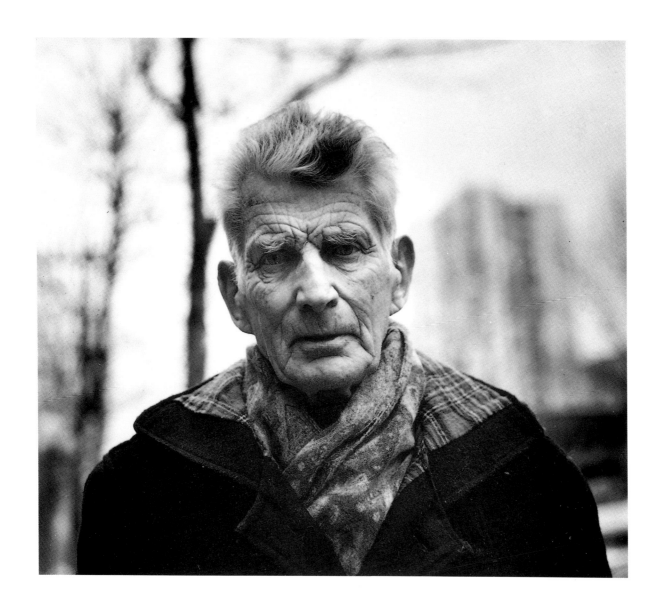

Beckett on the Boulevard St Jacques

I shall always remember his shy, gentle courtesy and his distinctive soft Dublin voice saying,
'God bless' as I said 'Goodbye' on the Boulevard St Jacques.

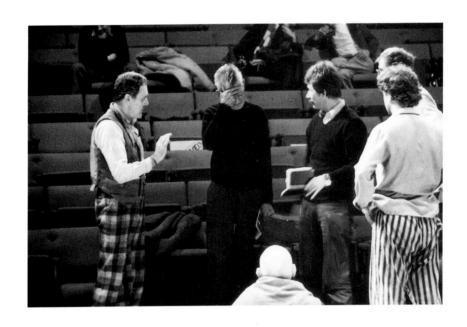

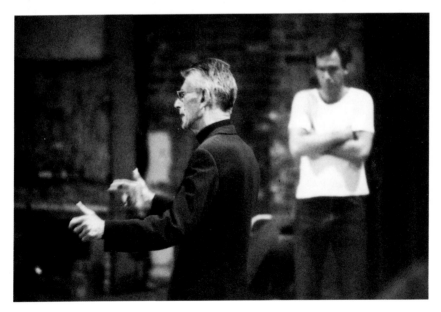

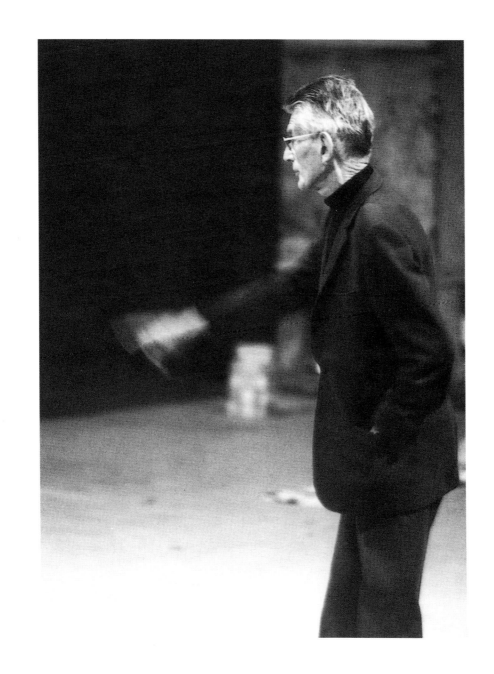

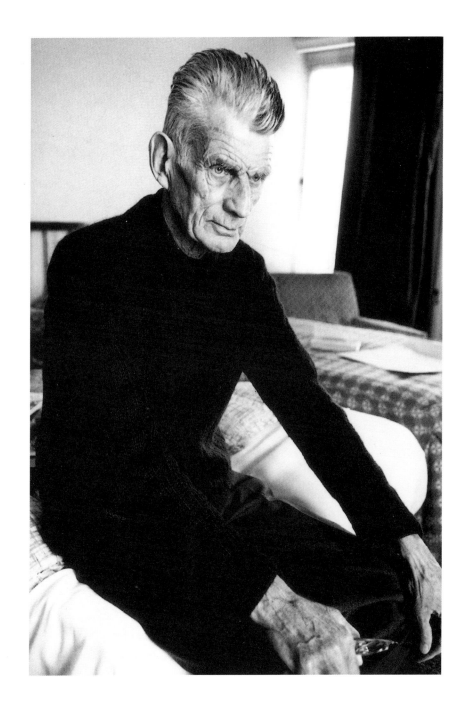

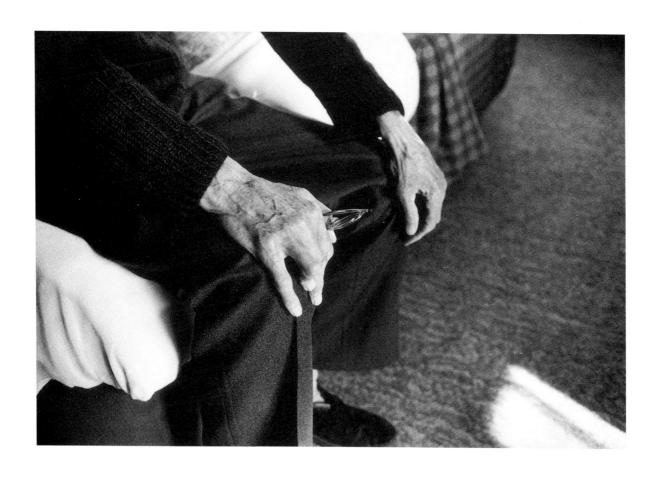

'Hamm: Did you never have the curiosity, while I was sleeping, to take off my glasses and look at my eyes?'
Endgame

'A country road. A tree. Evening.'
Waiting for Godot

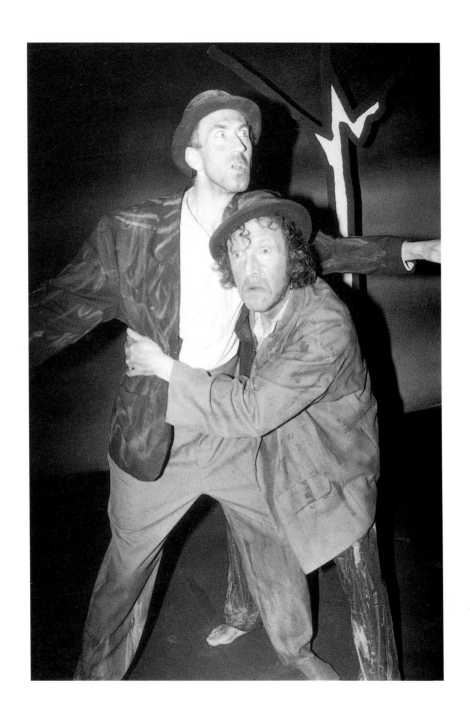

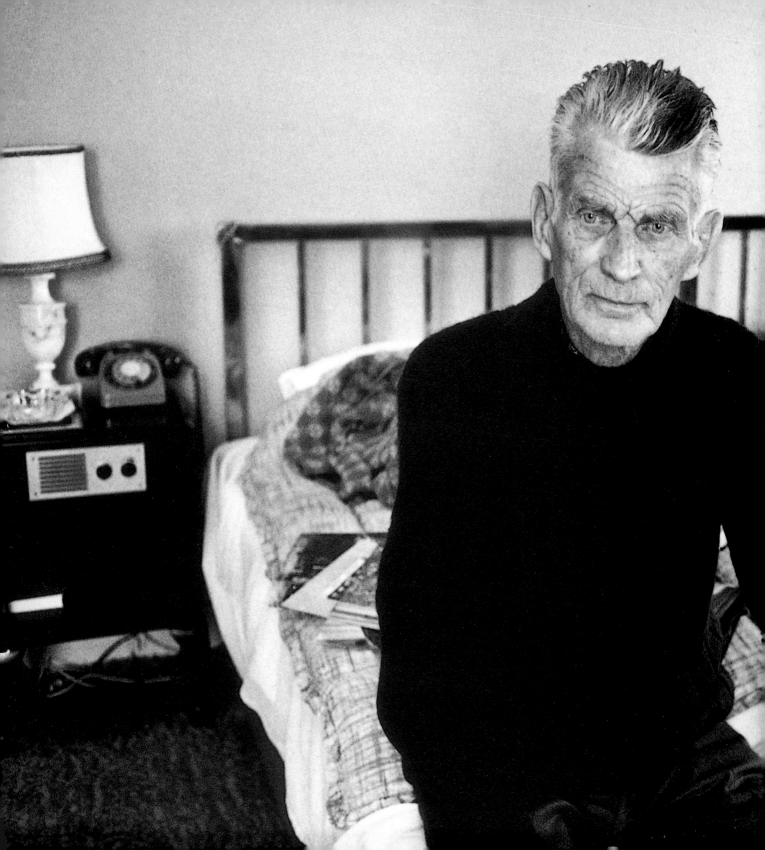

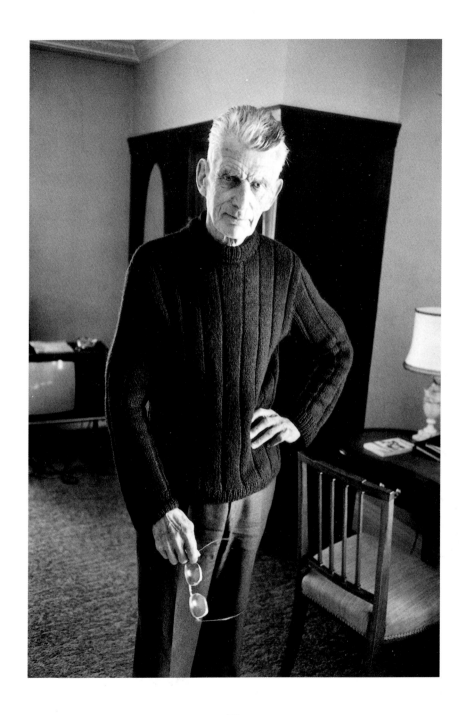

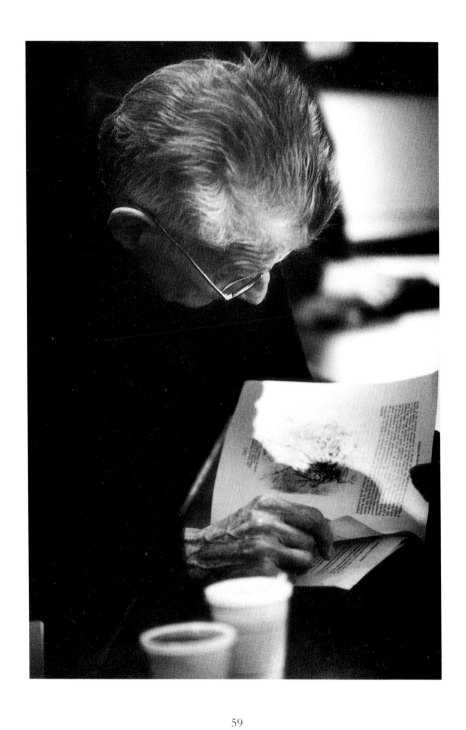

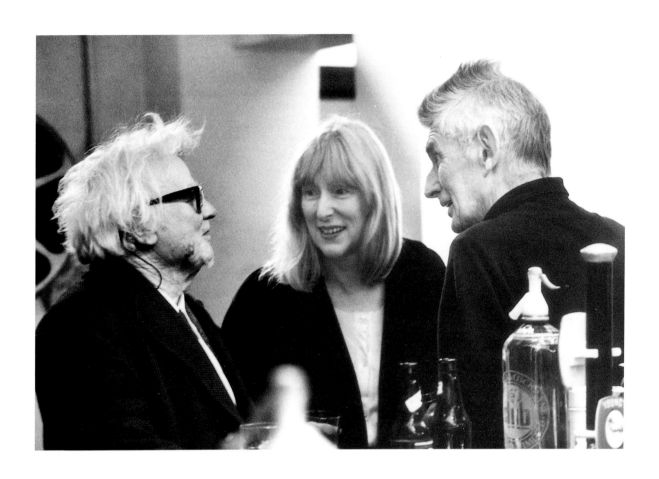

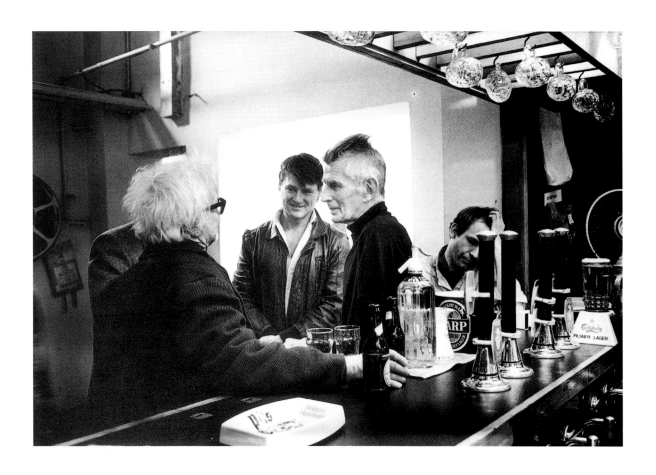

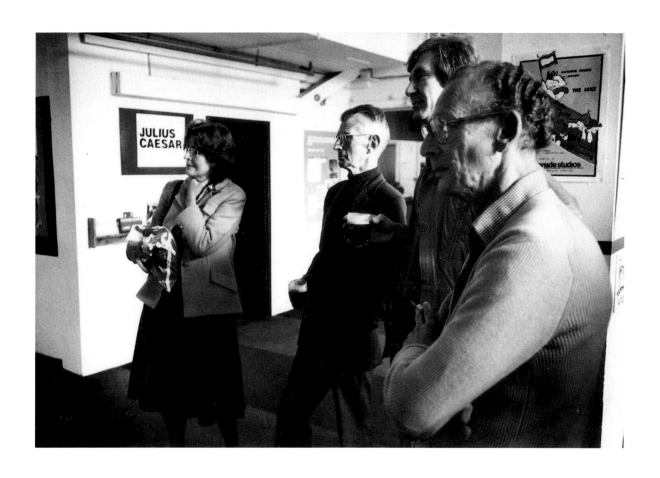

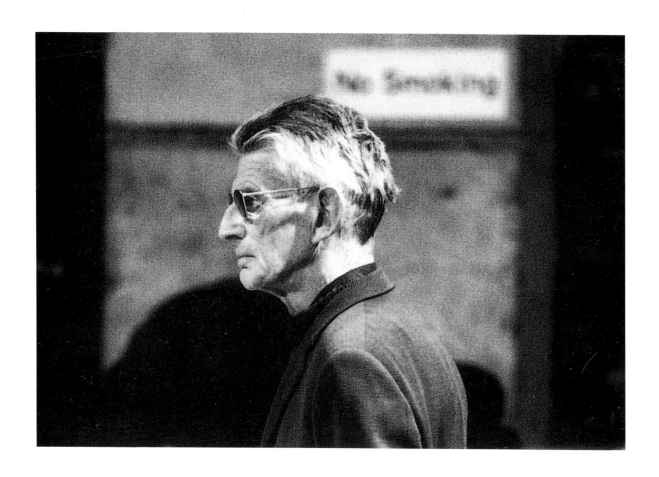

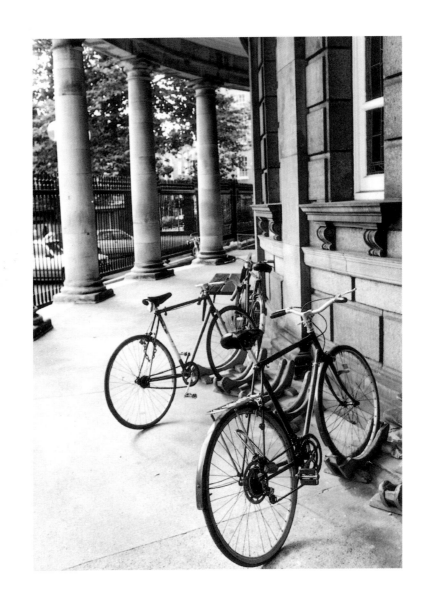

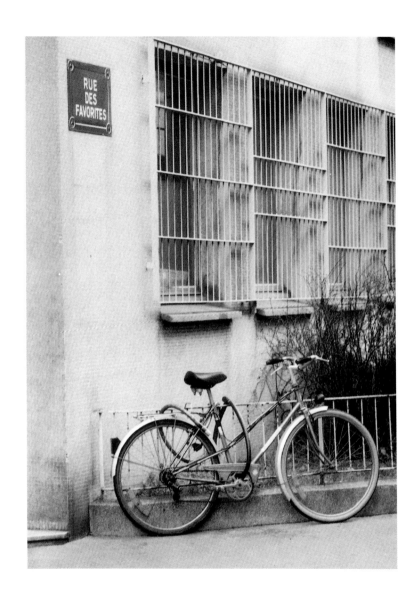

Samuel Beckett lived on the Rue des Favorites from 1938 until he moved to the
Boulevard St Jacques in 1961, where he had a larger apartment overlooking the Santé prison.
Beckett had an affection for the bicycle.

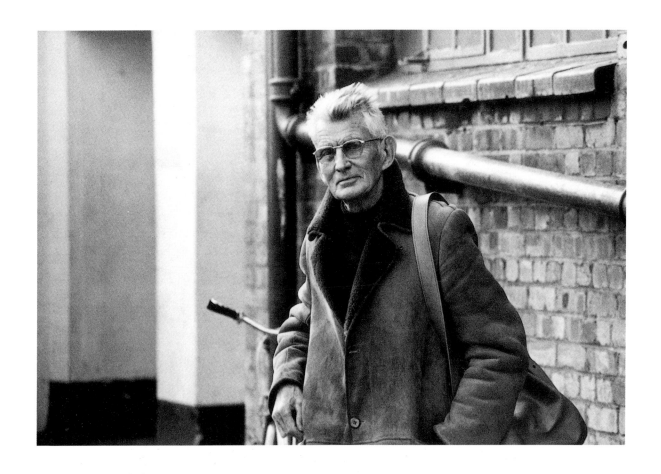

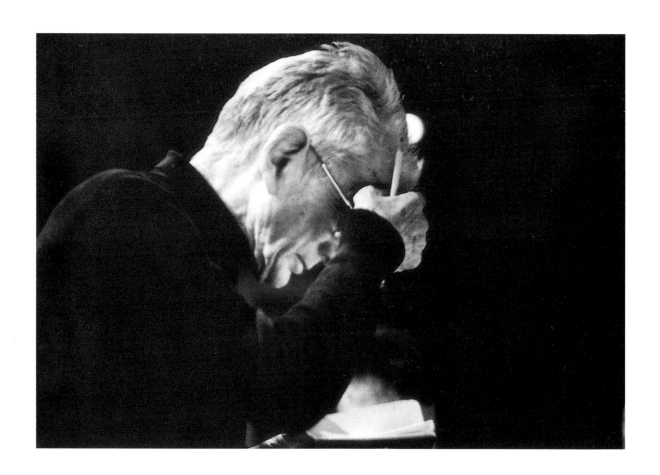

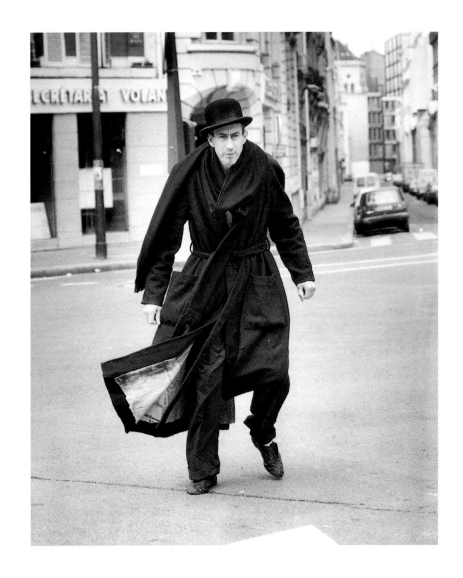

Barry McGovern pictured in Paris dressed for his one-man Beckett revue *I'll Go On*

'. . . in winter, under my greatcoat, I wrapped myself in swathes of newspaper . . .
The *Times Literary Supplement* was admirably adapted to this purpose.'

Molloy

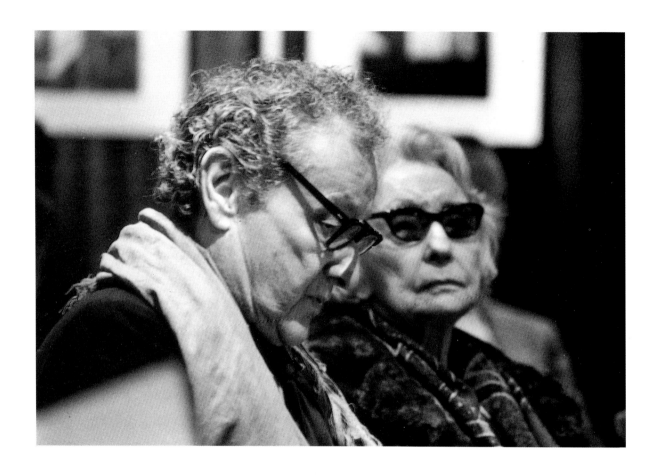

Jean-Louis Barrault and Madeleine Renaud pictured in Paris in 1985.

'He was always there, terribly present and yet silent.'
Madeleine Renaud

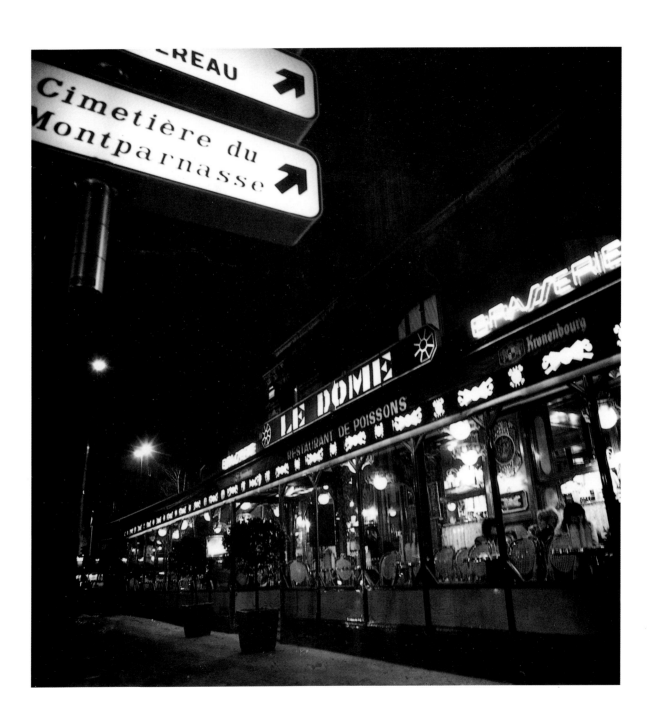

Beckett habitually met friends and
visitors in cafés on the Left Bank.

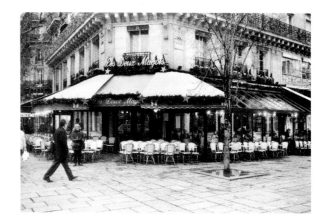

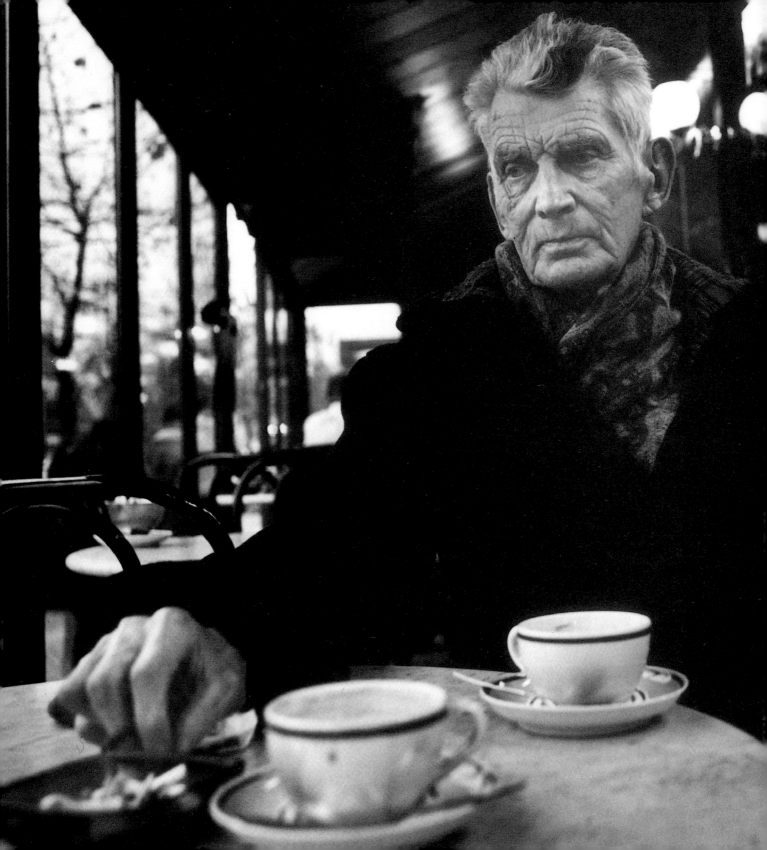

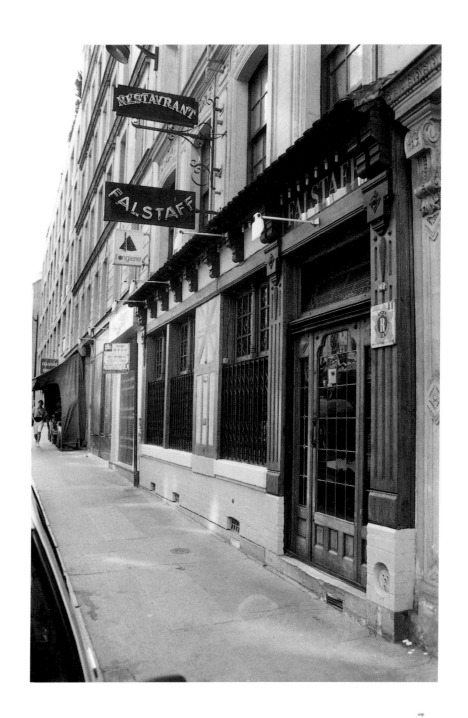

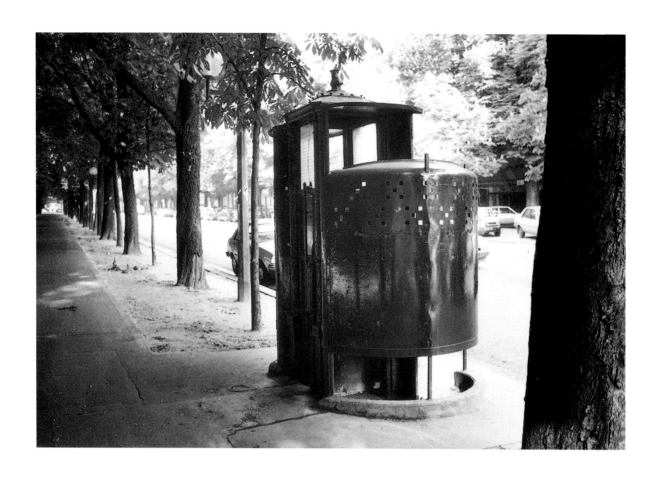

The last pissoir – just behind the Santé prison.
Sam would often stop to use this pissoir while out walking.

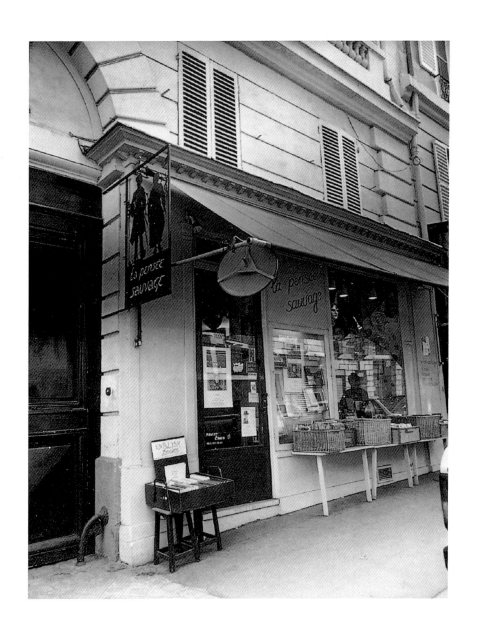

The site of Shakespeare & Co, founded by Sylvia Beach and Adrienne Monnier.
It became a meeting place for artists.

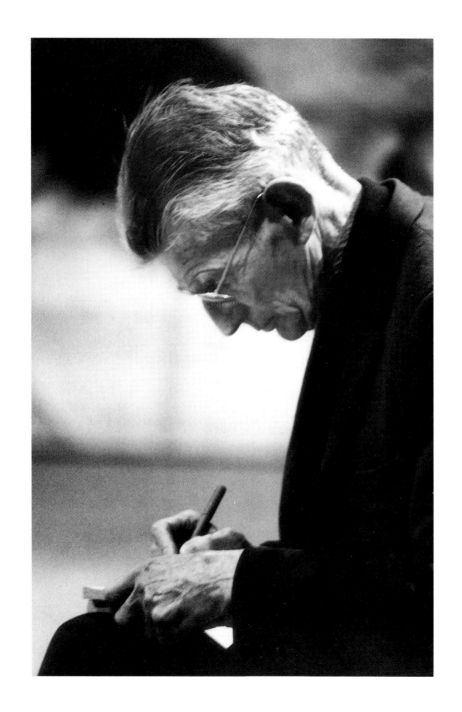

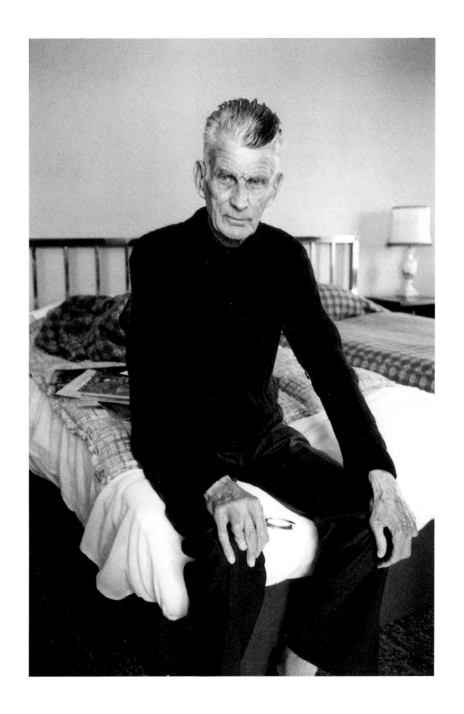

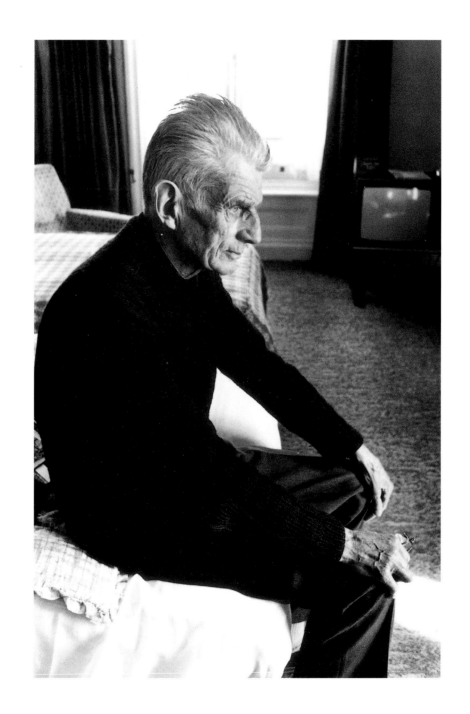

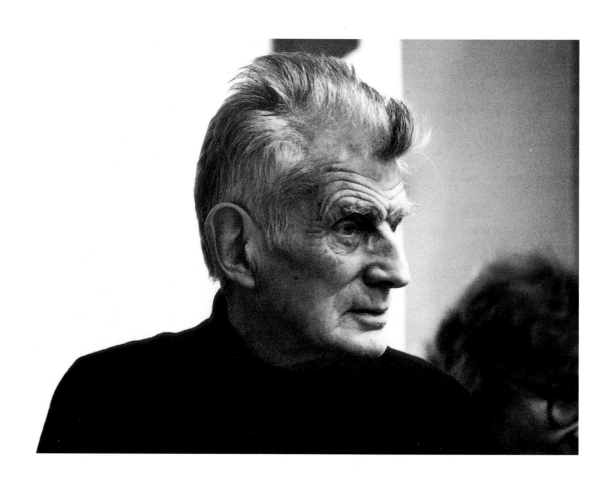

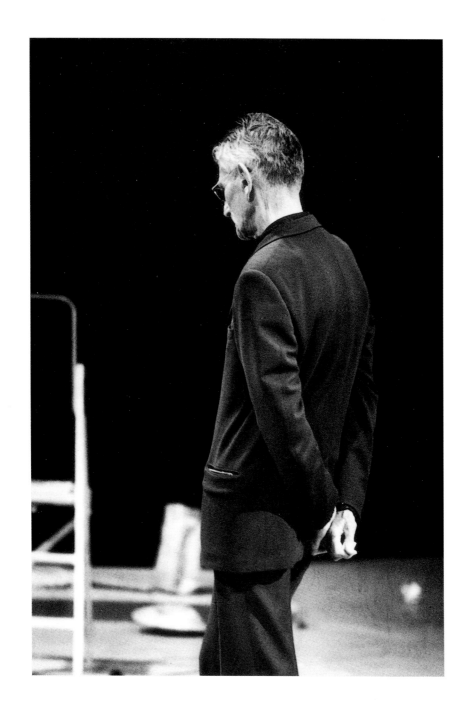

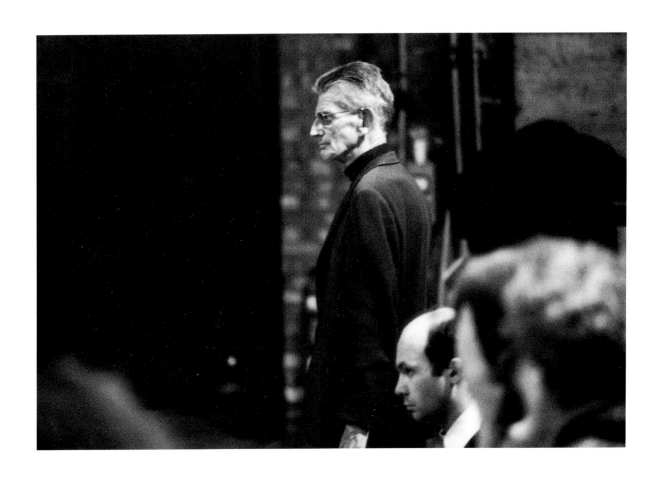

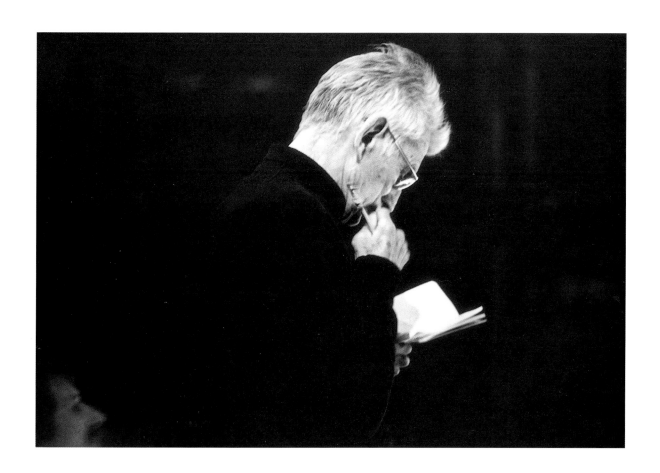

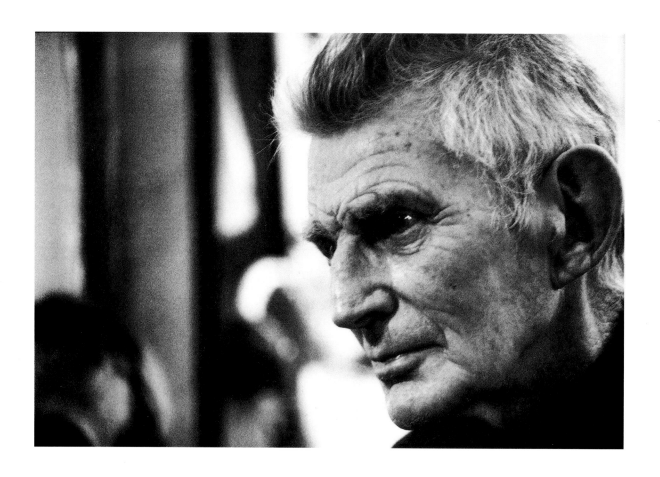

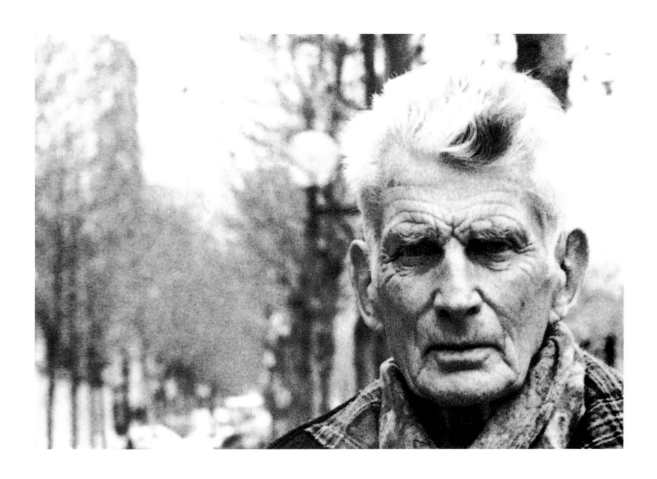

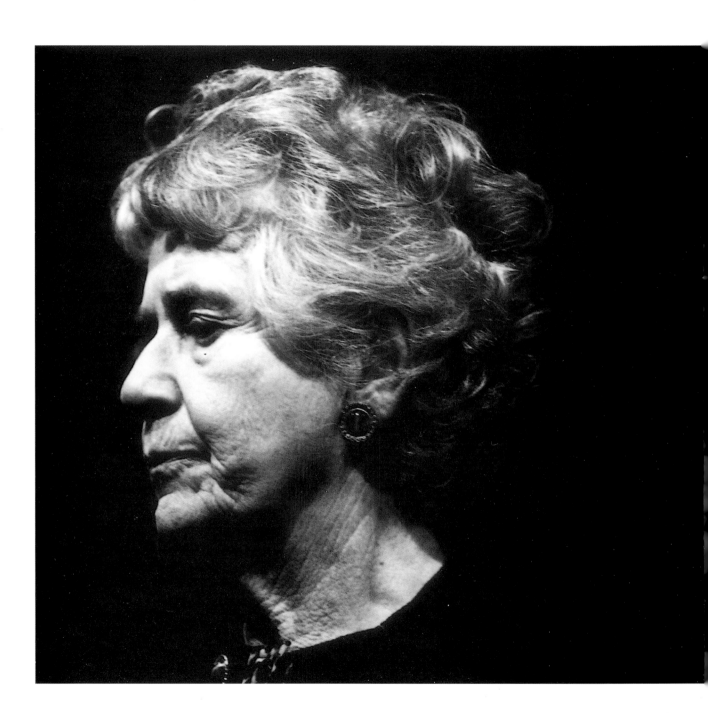

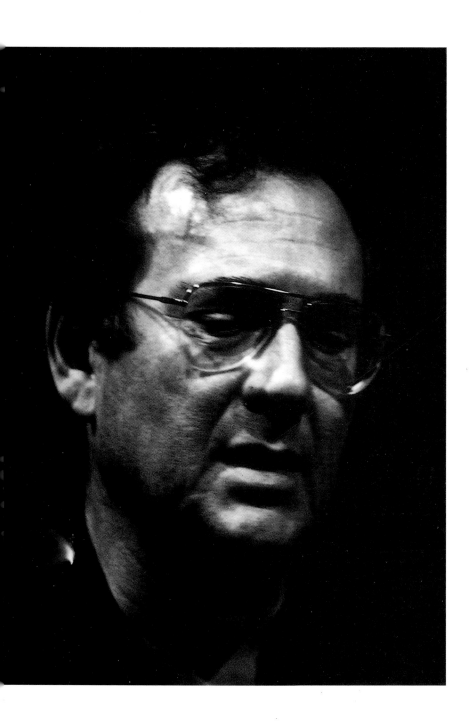

A celebration of the life and
work of Samuel Beckett,
Olivier Theatre, April 1990

Dame Peggy Ashcroft
reading from *Watt*.

Harold Pinter reading from
The Unnameable.

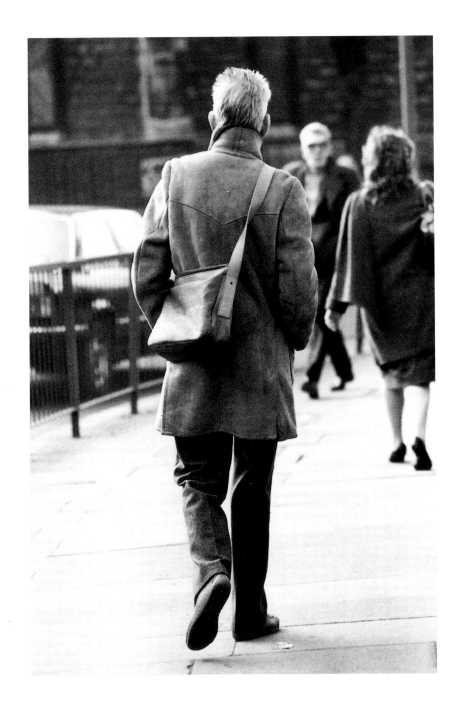

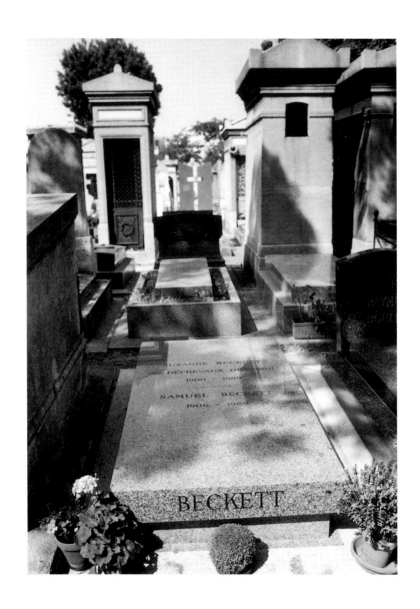

Dublin
1/250 @ F5.6

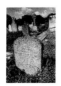

Dublin
1/500 @ F11

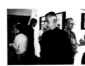

London
1/60 @ F5.6

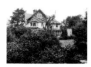

Dublin
1/500 @ F5.6

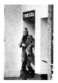

London
1/250 @ F4

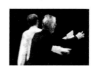

London
1/30 @ F4

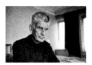

London
1/125 @ F4

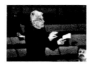

London
1/30 @ F4

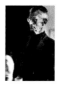

London
1/60 @ F4

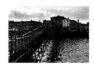

Dublin
1/125 @ F5.6

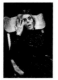

London
1/60 @ F4

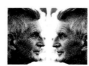

London
1/60 @ F5.6

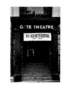

Dublin
1/250 @ F5.6

London
1/125 @ F5.6

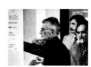

London
1/60 @ F5.6

Dublin
1/60 @ F5.6

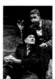

London
1/125 @ F4

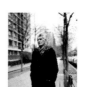

Paris
1/125 @ F4

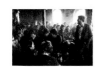

Dublin
1/60 @ F5.6

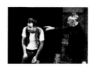

London
1/30 @ F4

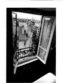

Paris
1/125 @ F5.6

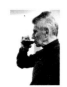

London
1/125 @ F4

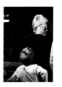

London
1/30 @ F4

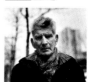

Paris
1/125 @ F4

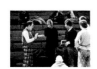

London
1/60 @ F4

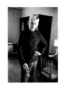

London
1/60 @ F4

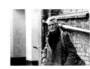

London
1/250 @ F4

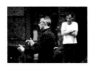

London
1/60 @ F4

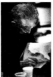

London
1/125 @ F4

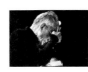

London
1/30 @ F4

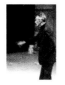

London
1/60 @ F4

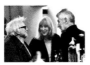

London
1/125 @ F4

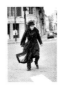

Paris
1/250 @ F5.6

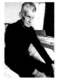

London
1/125 @ F5.6

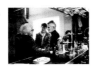

London
1/125 @ F4

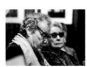

Paris
1/60 @ F5.6

London
1/125 @ F5.6

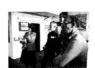

London
1/125 @ F4

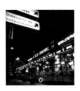

Paris
1/8 @ F4

Oxfordshire
1/500 @ F11

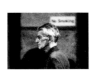

London
1/30 @ F4

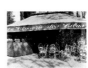

Paris
1/250 @ F4

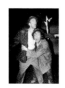

Dublin
1/125 @ F11

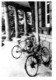

Dublin
1/125 @ F5.6

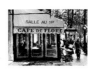

Paris
1/125 @ F4

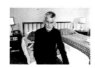

London
1/125 @ F5.6

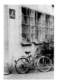

Paris
1/250 @ F4

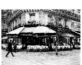

Paris
1/250 @ F5.6

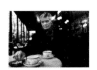

Paris
1/30 @ F4

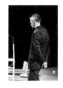

London
1/30 @ F4

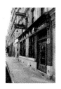

Paris
1/60 @ F4

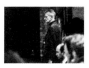

London
1/30 @ F4

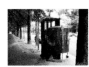

Paris
1/125 @ F4

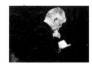

London
1/30 @ F4

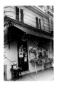

Paris
1/125 @ F5.6

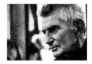

London
1/60 @ F4

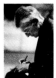

London
1/60 @ F4

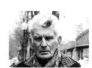

Paris
1/125 @ F4

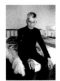

London
1/125 @ F4

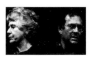

London
1/30 @ F4

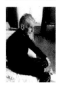

London
1/60 @ F4

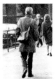

London
1/250 @ F5.6

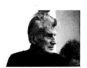

London
1/60 @ F4

Paris
1/125 @ F5.6

I would like to express my gratitude, for their
contribution to this book, to Olympus Cameras
UK Ltd, who have always supported my
photography. All the photos in this book have
been taken with an Olympus, Nikon or
Hasselblad camera. J.M.